IMAGES
of America

SAN FRANCISCO'S
RICHMOND
DISTRICT

IMAGES
of America

SAN FRANCISCO'S
RICHMOND
DISTRICT

Lorri Ungaretti

Published by Arcadia Publishing
Charleston SC, Chicago IL, Portsmouth NH, San Francisco CA

Printed in Great Britain

Library of Congress Catalog Card Number: 2005929438

For all general information contact Arcadia Publishing at:
Telephone 843-853-2070
Fax 843-853-0044
E-mail sales@arcadiapublishing.com
For customer service and orders:
Toll-Free 1-888-313-2665

Visit us on the internet at http://www.arcadiapublishing.com

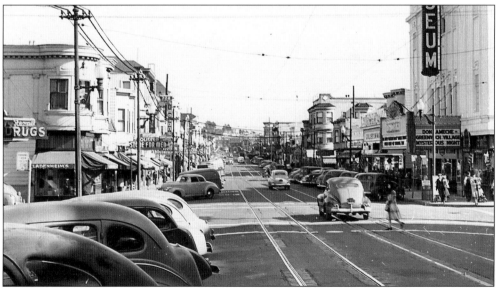

COVER AND ABOVE: In 1944, Clement Street between Ninth and Tenth Avenues was a thriving business area without the crowds and traffic that clog the area today. This view looking east shows the Coliseum Theatre on the right and the No. 2 streetcar tracks running down the street. (Courtesy of San Francisco History Center, San Francisco Public Library.)

CONTENTS

ACKNOWLEDGMENTS

Special thanks to John Freeman, who probably knows the history of the Richmond District better than anyone. Without his knowledge, support, and friendship, I could not have written this book. I also appreciate the generosity of Richard Brandi, Emiliano Echeverria, and Jack Tillmany. Others who helped are listed below. Thanks to you all.

Mark Adams, Pat Akre, anonymous private collector, Morrie Bobrow, Dorothy Bryant, California Historical Society, Virginia Bunting Cornyn, Dorothy Noble Cox, Janine DeFao, Rita Dunn, Joe Fama, Peter Field, Paula Freedman, Philip Laborio Gangi, Gary Goss, Oliver Hack, Barbara Hartley, Hiller Aviation Museum, Isabel Nadel Hogan, Inge Horton, Kevin Hunsanger, Linda Tigges Kayden, Glen Koch, Woody LaBounty, Martin Larkin, Joan Liuzzi, Angus MacFarlane, Darius Meykadeh, Bob Mahoney, Christine Miller, Tallulah Mirabito, Karl, Mondon, Terry O'Brien, Tricia O'Brien, Rita O'Hara, Jamie O'Keefe, Julie Norris O'Keefe, Dennis O'Rorke, Miriam Ritter, Jim Rowland, Staff at San Francisco History Center of the San Francisco Public Library, Evie Schoepp, Ellie Shattuck, Richard Slezak, Susan Snyder, Ron Stephenson, Brian Swanson of Pacific Gas and Electric Company, Diane Titov, Paul Totah, Walter Vielbaum, Peggy Vincent, Tom Vincent, North West, Monica Williams, and Rafael Zevallos-Crowe.

INTRODUCTION

In the 1800s, what is now the Richmond District was part of "The Outside Lands," which were not part of the City of San Francisco, and in those days, no one believed that the Outside Lands would ever be part of the city. Early maps called the area "Great Sand Bank" because it was composed primarily of sand dunes. Originally owned by Mexico, the Outside Lands were annexed by the U.S. government in 1848 and made part of the City and County of San Francisco in 1866. At that time, the city set aside parts of this land for parks (including the 1,017-acre Golden Gate Park), schools, fire stations, and a city cemetery.

How did this northern part of the Outside Lands come to be known as the Richmond District? In 1876, George Turner Marsh (1857–1932) came to San Francisco and in the 1880s built a home at Twelfth Avenue and Clement Street. He named the home "Richmond House" in honor of his birthplace, Richmond, Australia. In 1890, the Point Lobos Improvement Club suggested the name "Richmond" for the entire district, honoring Marsh's early residency and standing in the neighborhood. On November 24, 1890, the board of supervisors designated the land that is now west of Arguello to the beach, from Golden Gate Park to the Presidio the Richmond District. (Some people name Masonic and Presidio as the eastern boundary of the Richmond. This book uses that boundary.)

In November 1917, the board of supervisors, to avoid confusion with the city of Richmond, passed an ordinance changing the name to Park-Presidio District. But the new name never really stuck.

People often lump together the Richmond District and the Sunset District. There are similarities: both districts were originally sand dunes and part of the Outside Lands; both are now heavily residential; both border Golden Gate Park; both have streets arranged in a grid pattern; and both have similar weather patterns—cold, foggy summers and clear, cleaner air than downtown. However, their histories are distinctly different. The Richmond District developed much earlier than the Sunset and in diverse ways.

Transportation came early to the Richmond District, starting with a toll road for horses and buggies in 1865. By 1888, riders could take a steam train to the beach to enjoy the sights at Sutro Heights, the Cliff House, and Sutro Baths.

The area was far from the center of the city and far from where most people thought they would ever want to live—a good place for cemeteries. The first cemetery was built in the Richmond District in 1854, and soon there were five in the area. According to Charles Lockwood (*Suddenly San Francisco*, 1978), people went to the cemeteries for a quiet respite: "On pleasant afternoons well-dressed families walked along the paths, with their maps and guidebooks in hand, while the

carriages rolled up and down the winding hills." After Golden Gate Park was built in the 1870s, people flocked there to rest and recreate.

The city continued to grow westward, and by the 1880s people began calling for the closure of the Richmond District cemeteries. Both residents and developers saw the Inner Richmond, where four of the five cemeteries sat, as fertile land—not for farms but for housing. Burials within city limits were prohibited by law after August 1901. With no new burials, maintenance of the cemeteries deteriorated, while looting and vandalism increased.

In 1909, City Cemetery was closed and converted to Lincoln Park. The board of supervisors tried to evict the remaining four cemeteries but met with voter resistance. In 1923, a state law was enacted allowing cities to close cemeteries, and in 1937, city voters agreed to close the four Richmond District cemeteries. Some cemetery owners had already begun removing remains; others fought the closure, with at least one cemetery (Laurel Hill) remaining in place until 1941. By 1950, all Richmond District cemeteries were gone and the land graded for development.

When people wanted to play, they went farther out in the Richmond District, past most of the cemeteries. Some of the entertainment was considered proper—for example, the Bay District Race Track, Sutro Baths, Chutes, and Playland-at-the-Beach. More dubious forms of entertainment included roadhouses and saloons, far from the eyes of neighbors or authorities. As the years passed and more people built homes in the Richmond District, those neighboring "eyes" were everywhere, and the unsavory destinations began to close.

This book is divided into six chapters. "Chapter One: The Early Years" looks at the 1800s and early 1900s, when few houses or businesses existed in the Richmond District. "Chapter Two: The Cemeteries" discusses the five cemeteries that covered land in the Richmond District between 1854 and the 1940s. "Chapter Three: Transportation" discusses steam trains, cable cars, and streetcars, and later the buses that run through the Richmond District today. "Chapter Four: The City's Playground" describes the race tracks, sports fields, roadhouses, and amusement parks that drew citizens to be entertained "outside" the city. "Chapter Five: Churches, Schools, and Other Public Buildings" features some of the structures and groups that helped meet the increasing needs of Richmond District residents. "Chapter Six: Daily Life" grows out of Chapter Five, showing some of the people and businesses that have been part of the neighborhood.

Many of the attractions that drew nonresidents to the Richmond District no longer exist. Most roadhouses and saloons were gone by 1900. The cemeteries disappeared between 1909 and 1941. Sutro Baths closed in 1964, and Playland-at-the-Beach was razed in 1972. But all of these destinations contributed to the rich history of this "Outside Lands" community. What remains is a thriving residential neighborhood—or, more accurately a group of neighborhoods—in the northwestern corner of San Francisco, the Outside Lands no more.

One

THE EARLY YEARS

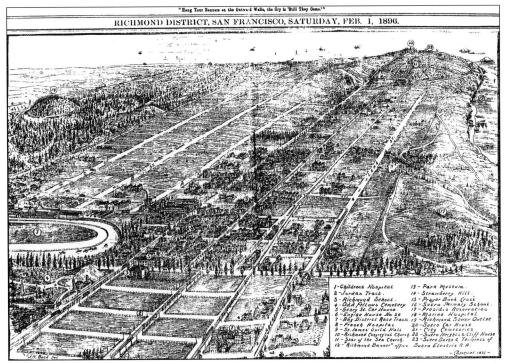

This 1886 map highlights some Richmond landmarks, including Odd Fellows Cemetery (4), the Bay District Race Track (7), the original Star of the Sea Church (11), Sutro Car House (20), the City Cemetery (21), Sutro Heights/Cliff House (22), and Sutro Baths (23). (Courtesy of Mark Adams.)

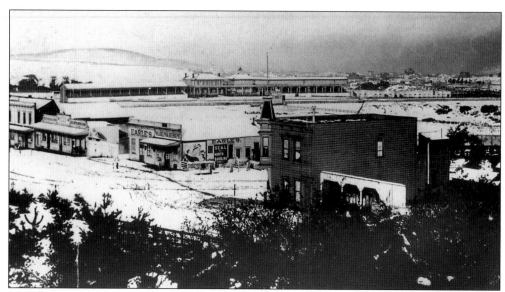

In 1882, a rare snow storm hit San Francisco. This view of the Richmond District shows the Bay District Race Track (see Chapter Four). The area was sparsely populated, but a few businesses operated on Fulton Street. (Courtesy of San Francisco History Center, San Francisco Public Library.)

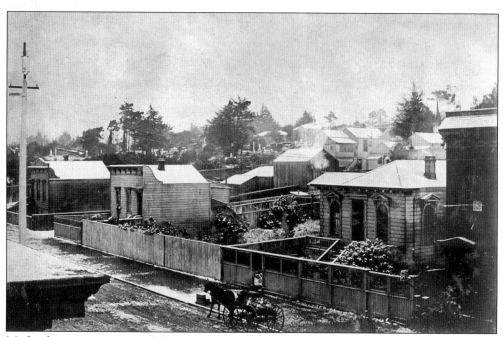

Modest homes were scattered along Cook Street in 1885. This photograph, taken north of Geary, shows Laurel Hill Cemetery (see page 26) in the background. Today apartment buildings cover the cemetery ground and new buildings line Cook Street. However, No. 46, the one-story building to the right of the horse and buggy, still stands. (Courtesy of The Bancroft Library, University of California.)

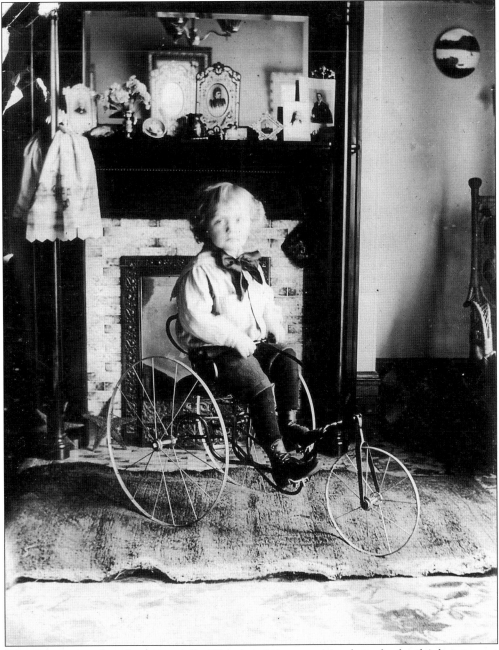

This rare interior shot shows young Earl Bunting sitting on a tricycle in the family's living room at 130 Fifth Avenue in 1895. (Courtesy of Virginia Bunting Cornyn.)

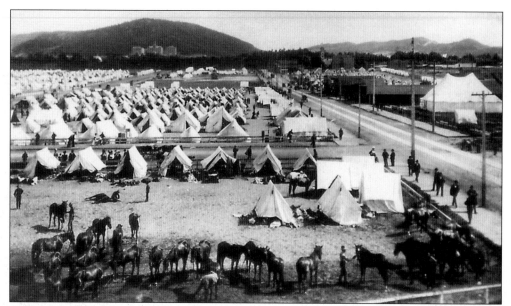

In 1898, the grounds of the recently closed Bay District Race Track (See Chapter Four) were taken over by the military as a staging area for troops preparing for combat in the Philippines during the Spanish-American War. The First Nebraska Volunteer Infantry arrived May 19–20, 1898, and 18,000 men were soon encamped at Camp Merritt. (Courtesy of San Francisco History Center, San Francisco Public Library.)

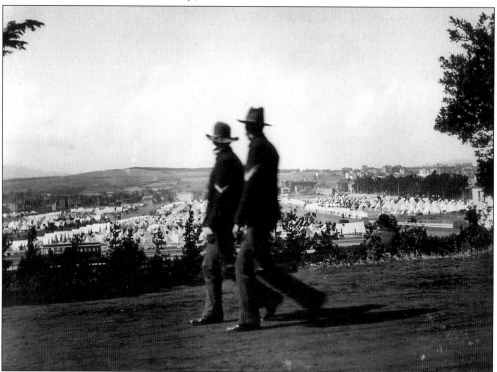

Two soldiers take a stroll in Golden Gate Park overlooking Camp Merritt in 1898. (Courtesy of a private collector.)

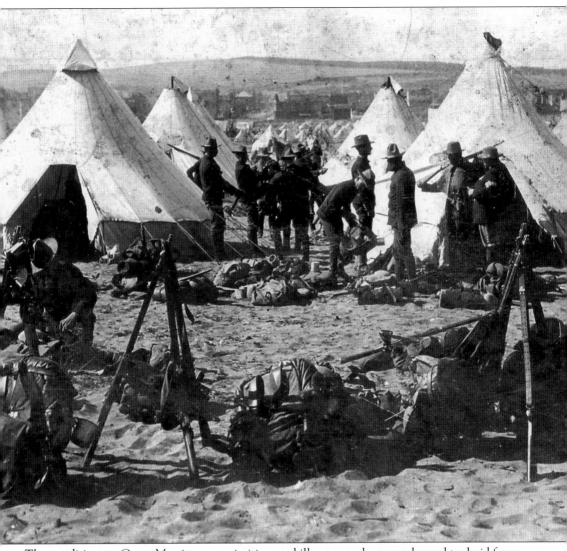

The conditions at Camp Merritt were primitive, and illnesses such as measles and typhoid fever ravaged the soldiers. (Courtesy of a private collector.)

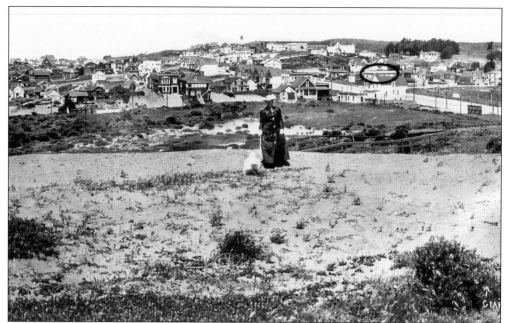

An unidentified woman walks her dog in the early 1900s in the dune that will someday be the site of George Washington High School. The photograph looks west from about Thirty-second Avenue. Geary is to the right. The circled building became the Pacific Cafe, pictured below. (Courtesy of a private collector.)

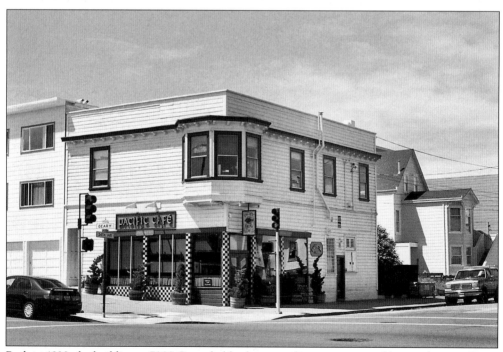

Built in 1899, the building at 7000 Geary held a drugstore for many years and later a cleaners. Since 1970, it has been home to the popular Pacific Cafe, founded by the late Jim Thompson, a former employee of the 1970s restaurant chain Victoria's Station. (Photograph by Lorri Ungaretti.)

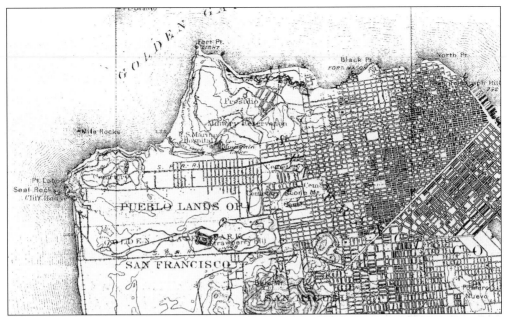

This U.S. Geological Survey map shows areas developed by 1900. The western area is described on this map as the "Pueblo Lands of San Francisco." The southern part became the Sunset District, the center area became Golden Gate Park, and the northern area (behind the words *Pueblo Lands of*) became the Richmond. Clearly, only blocks along transit lines were developed at this point. The Bay District Race Track appears just to the right of the word *of*. (Courtesy of Richard Brandi.)

This lonely house, photographed around 1900, sits among the sand dunes that became the Richmond District. The photograph looks south toward Golden Gate Park. Sweeney's Observatory (destroyed in 1906) atop Strawberry Hill is at the upper left of the photograph. (Courtesy of a private collector.)

15

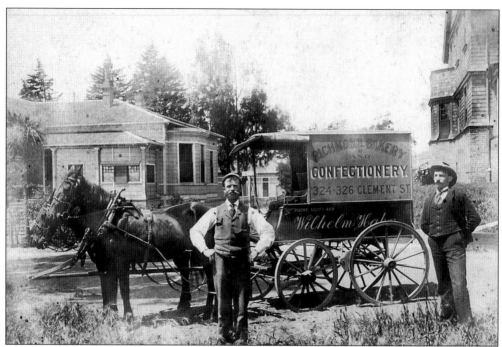

In 1904, "Grandpa Sattler" and Wilhelm Hahn pose for the camera in front of the buggy advertising Mr. Hahn's store on Clement Street, the retail hub of the Richmond at this time. (Courtesy of John Freeman.)

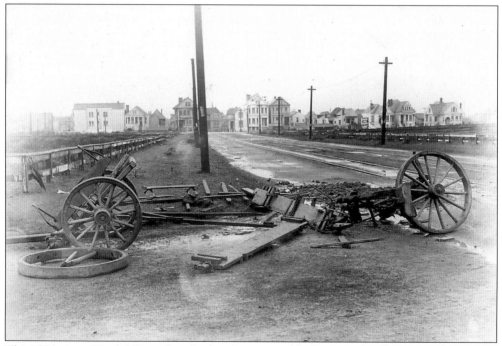

This 1904 view of Euclid Street from Jordan shows some blocks covered with houses, while others were open and unused. Who destroyed the wagon, and how long did the wreckage lie there? (Courtesy of Emiliano Echeverria.)

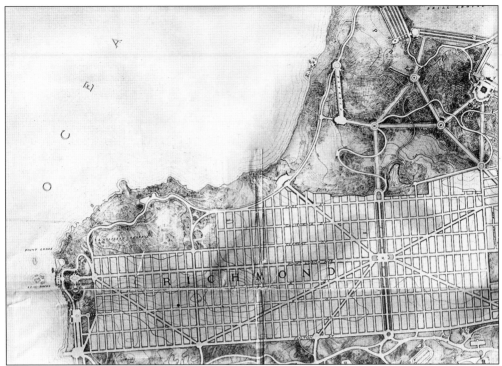

In 1905, Chicago architect Daniel Burnham proposed the Burnham Plan for redesigning the streets of San Francisco. Among other ideas, Burnham suggested creating a north-south boulevard in the Richmond District with wide streets radiating from it diagonally to break up the neighborhood's grid pattern. The north-south boulevard was Park Presidio, already in the city's plans, but the rest of the Burnham Plan for the Richmond was never pursued.

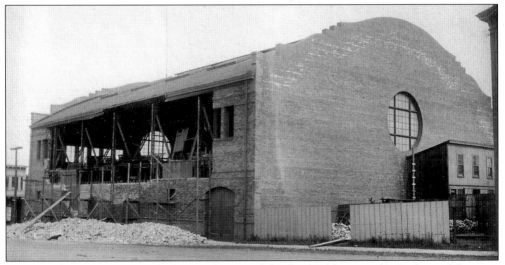

The 1906 earthquake severely damaged many of the few buildings in the Richmond District, including the new St. John's Presbyterian Church, the French Hospital, and the Columbarium in Odd Fellows Cemetery. Shown above is the St. Francis Riding Academy, built in 1904 at Seventh Avenue and C (now Cabrillo) Street. The academy's brick wall collapsed onto C Street. (Courtesy of John Freeman.)

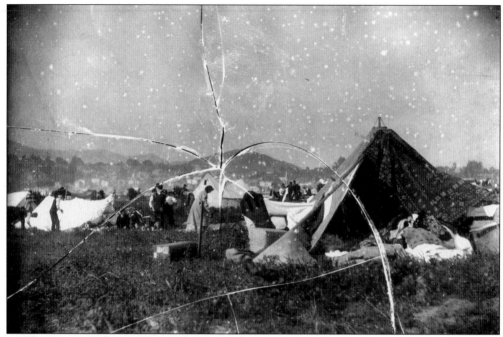

After the 1906 earthquake and fire, many refugees stayed in tents set up in parks. The lines in this photograph are from the original glass plate, which was part of a mobile before the current owner "rescued" it at a garage sale. (Courtesy of a private collector.)

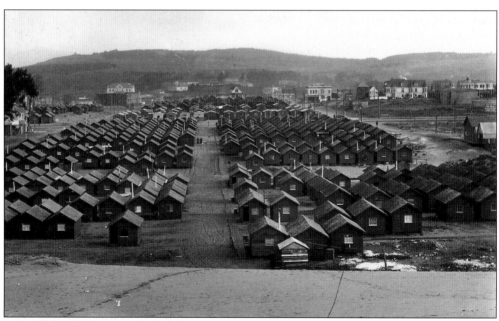

After the 1906 disaster, temporary "camp cottages" were built to house refugees. About 1,600 cottages comprised Camp Richmond (shown here), which opened in November 1906 in the area where Park Presidio Boulevard now runs. By 1907, more than 4,000 people lived in Camp Richmond. The camp closed in January 1908. Of the 5,610 cottages placed around San Francisco in 1906, only about 20 have been identified as still in existence. (Courtesy of a private collector.)

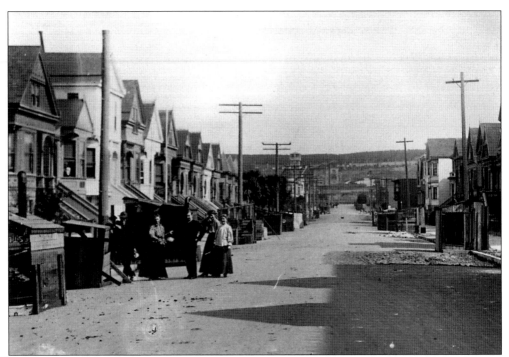

People stayed in their homes if they were not severely damaged, but cooking inside was not allowed for fear of additional fires breaking out. This Third Avenue photograph shows the shacks that held stoves on the street. (Courtesy of a private collector.)

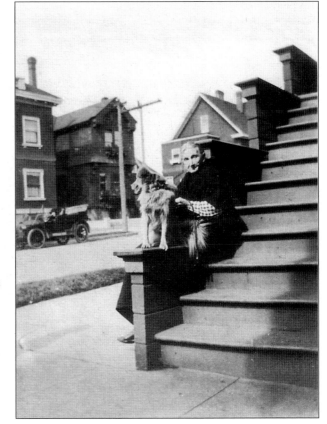

Virginia Bunting's grandparents owned this house at 130 Fifth Avenue. In this undated photograph, Virginia Bunting's great-grandmother rests on the stairs. Although this house no longer exists, several of the ones across the street still stand. (Courtesy of Virginia Bunting Cornyn.)

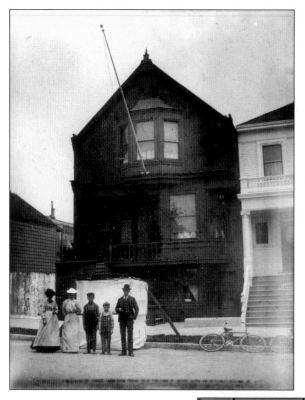

The Bunting family poses in front of their house at 130 Fifth Avenue after the 1906 earthquake. The canvas in the background covered their curbside kitchen. Pictured, from left to right, are Virginia's great-grandmother, grandmother, uncle (Earl), father (Elwood), and grandfather (William). The 50-foot-long wooden flagpole came from a ship on which William Bunting had served. (Courtesy of Virginia Bunting Cornyn.)

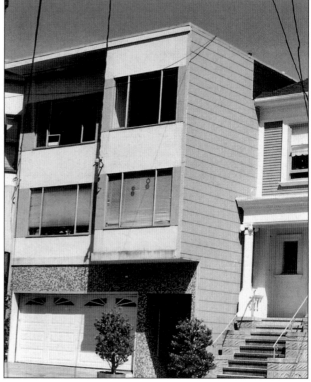

In the 1960s and 1970s, people began razing single-dwelling homes and replacing them with apartment buildings that became known as "Richmond Specials." The Bunting house at 130 Fifth Avenue has been replaced by a Richmond Special, but the house next door remains. In March 1988, the board of supervisors placed a moratorium on "Richmond Specials," making it more difficult for people to tear down homes in the neighborhood. (Photograph by Lorri Ungaretti.)

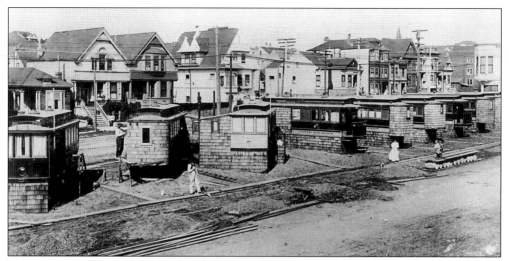

In late 1906, Dr. Charles V. Cross placed obsolete cable cars on the block of Cornwall Street between Fourth and Fifth Avenues and called them the Carzonia (or Carsonia) Apartments—although he liked to call the area Charring Cross Corners. According to the *Richmond Banner*, "The property owners in the neighborhood are very much annoyed, as they consider them a disgrace to their neighborhood." But Dr. Cross, who planned to live in one of the cable car bungalows, asked people to have "a little patience till the work is completed into artistic living apartments, surrounded with pretty flowers and will be attractive." (Courtesy of a private collector.)

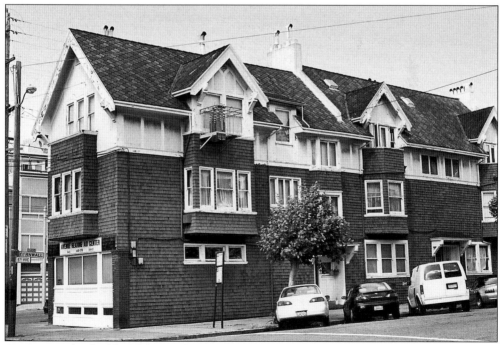

Since 1911, this building has stood on Cornwall Street at the site of Carzonia. (Photograph by Lorri Ungaretti.)

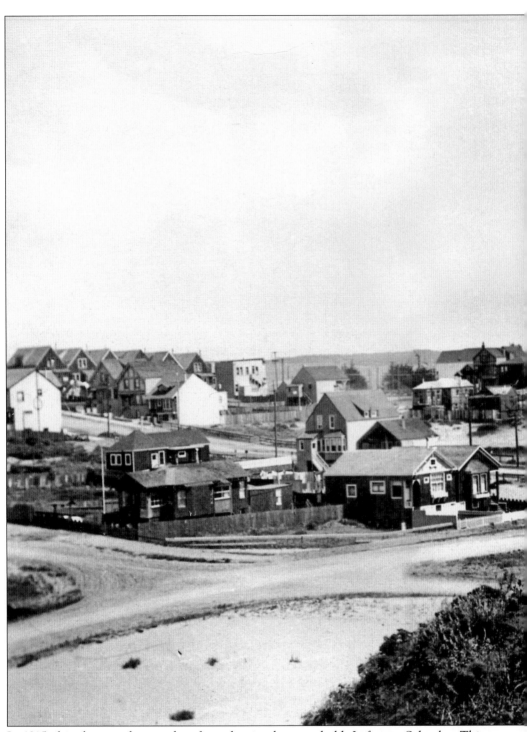

In 1915, this photograph was taken from the site that now holds Lafayette School at Thirty-sixth Avenue and Anza Street. The two small, dark cottages pictured just left of center used to be connected. According to the current owner, residents passed food between a cupboard in adjoining kitchens. The cottage on the left has been replaced by an apartment building. The one

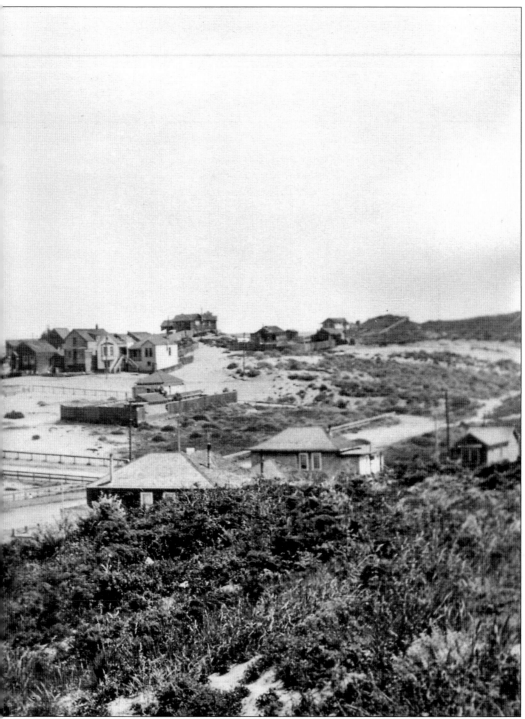

on the right still stands but has a third-floor addition. The tall house behind the cottages still stands, as do some of the peaked-roofed buildings on Geary on the left side of the photograph. (Courtesy of Diane Titov.)

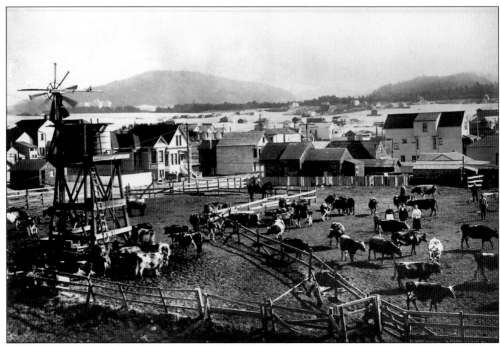

This rare photograph, taken from Twenty-second Avenue and Clement Street in 1908, shows one of the numerous Richmond District farms in the early 20th century. (Courtesy of a private collector.)

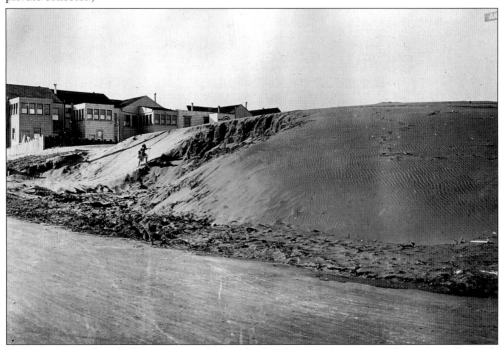

In 1914, this unidentified person struggled to climb a dune on Anza Street between Eighteenth and Nineteenth Avenues. Street grading and building had begun, but hills of sand still comprised much of the area. (Courtesy of a private collector.)

Two

THE CEMETERIES

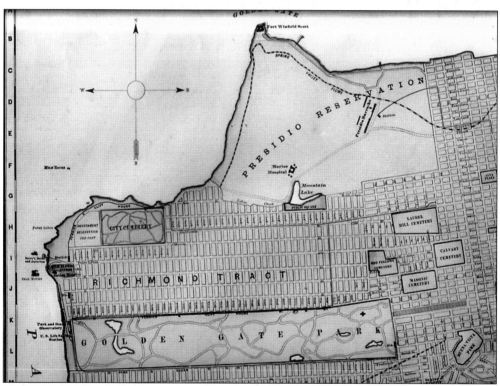

This 1891 map shows the five cemeteries in the northwestern part of San Francisco in the late 1800s. Clustered together at the eastern end of the Richmond District were Laurel Hill, Calvary, Masonic, and Odd Fellows cemeteries. City Cemetery (also called Golden Gate Cemetery, later Lincoln Park and Fort Miley) lay in the far northwestern end of the neighborhood. (Courtesy of Richard Brandi.)

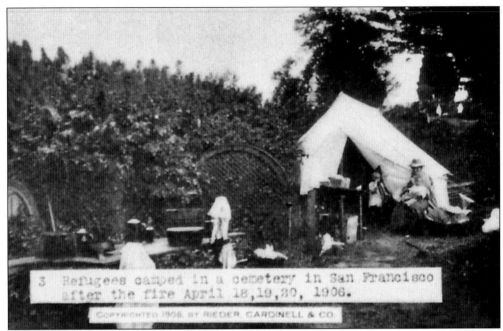

After losing their homes in the 1906 earthquake and fire, many people lived temporarily in tents erected in parks and cemeteries. This picture was taken at an unidentified San Francisco cemetery. (Courtesy of San Francisco History Center, San Francisco Public Library.)

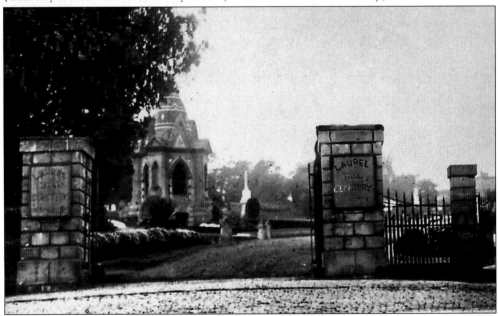

Dedicated in 1854, Lone Mountain Cemetery was named in honor of the hill a half-mile south of the cemetery. The name changed to Laurel Hill Cemetery in 1867. The cemetery boundaries were approximately California, Euclid, Parker, and Cemetery (later Central and now Presidio). This photograph shows the main entrance to Laurel Hill Cemetery, the earliest cemetery in the neighborhood and one of the last removed from the city. (Courtesy of San Francisco History Center, San Francisco Public Library.)

John Orr's gravestone in Laurel Hill read, "In memory of the first inhabitant of this silent city—John Orr, Interred June 10, 1854." A 1961 plaque on the brick wall on California Street at Walnut, declares the spot California Registered Historical Landmark No. 760 and reads, "The builders of the west, civic and military leaders, jurists, inventors, artists, and eleven United States senators were buried here—the most revered of San Francisco's hills." (Courtesy of San Francisco History Center, San Francisco Public Library.)

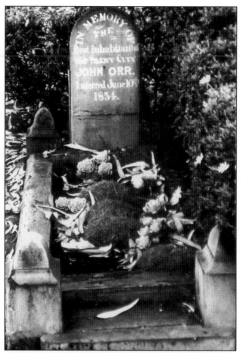

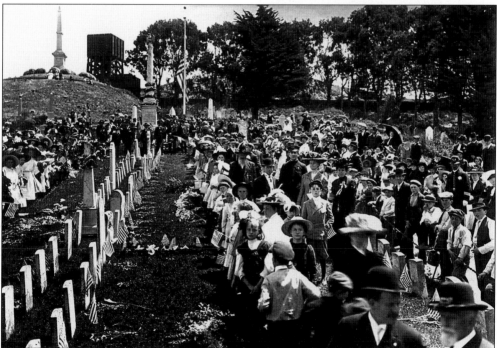

People wore their best clothes for the festivities of the Grand Army of the Republic (GAR) in Laurel Hill Cemetery on Memorial Day, 1909. According to the book *Portals of the Past* (1992), the cemetery was a "western showplace, laid out with 20 miles of wide avenues and winding paths. Native oaks curled, twisted and drooped over graves. It was the single oasis of tranquility in a monotonous and treeless city." (Courtesy of a private collector.)

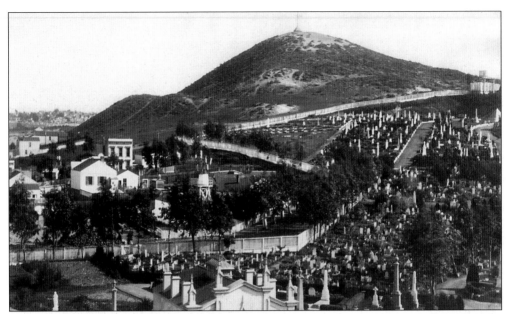

Until 1930, several versions of a wooden cross stood at the top of Lone Mountain. (Jim Rowland, who lived in the area as a child in the 1930s, called it "Cross Hill.") The photograph above, taken in the late 1800s, shows Laurel Hill Cemetery below Lone Mountain. The bottom photograph, taken in 1985, shows Lone Mountain College (now part of the University of San Francisco) and the residences that replaced the cemetery. The streets created after the removal of this cemetery include Mayfair, Heather, Iris, Manzanita, Laurel, Wood, and Lupine. (Courtesy of a private collector.)

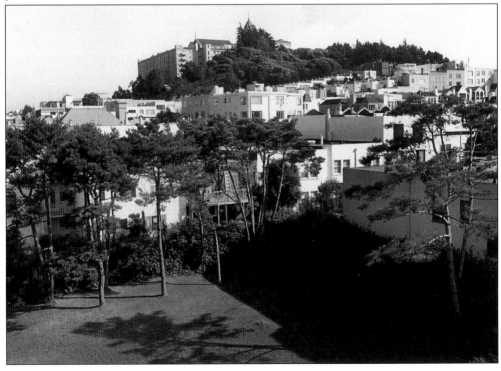

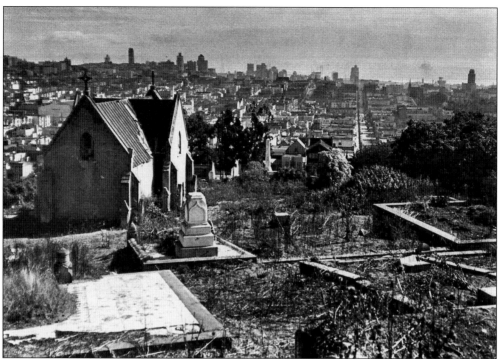

This 1940 photograph shows the growing city east of Laurel Hill Cemetery. Workers had begun removing the gravestones and remains. Consequently, the cemetery was no longer well maintained and was often the victim of looters and vandals. Between 1940 and 1945, approximately 35,000 bodies were removed from Laurel Hill Cemetery to Cypress Lawn Cemetery in Colma. (Courtesy of San Francisco History Center, San Francisco Public Library.)

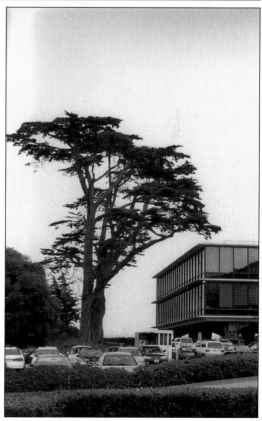

One corner of Laurel Hill Cemetery was originally held by the city as the site for the new Lowell High School. When another site was selected, the city sold the land to Fireman's Fund in the 1950s. According to Harold Gilliam (*The Natural World of San Francisco,* 1967), two Monterey cypress trees planted in the cemetery in the 1800s "were retained when the cemetery was moved and the company took over the hill." When Firemen's Fund expanded in 1965, it spent thousands of dollars to preserve the two trees, one of which is shown in this photograph. The site has been the UCSF Laurel Heights campus since 1985. (Photograph by Lorri Ungaretti.)

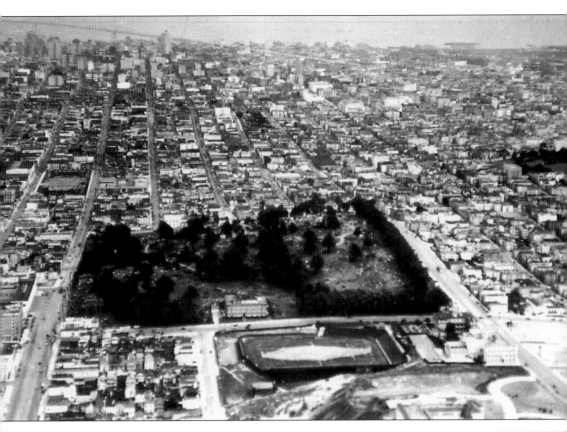

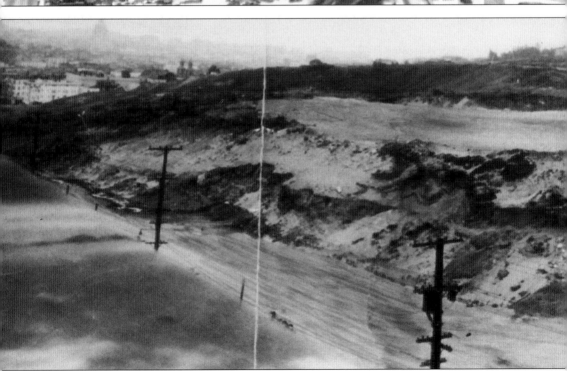

OPPOSITE: Calvary Cemetery opened in 1860 for Roman Catholics. The cemetery sat primarily in the Western Addition neighborhood, and only the western edge spilled over into the Richmond District. In this 1939 aerial photograph facing downtown, Calvary Cemetery looks like a park surrounded by a densely populated city. Geary runs along the left-hand side and Turk Street along the right-hand side. Ewing Field (see page 58) is clearly visible below the cemetery. (Courtesy of San Francisco History Center, San Francisco Public Library.)

BELOW: Between 1939 and 1941, approximately 55,000 bodies were removed from Calvary Cemetery's 49.2 acres to Holy Cross Cemetery in Colma. The news article that accompanied this photograph on August 26, 1946, said, "Here's San Francisco's historic Calvary Cemetery as it looks today—the monument to illustrious dead moved and the ground swept clear by machines to provide space for new development of housing." (Courtesy of San Francisco History Center, San Francisco Public Library.)

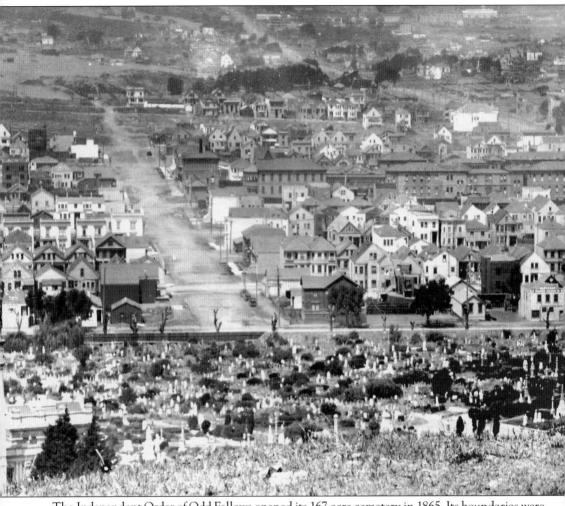

The Independent Order of Odd Fellows opened its 167-acre cemetery in 1865. Its boundaries were irregular, approximately within Arguello, Geary, Stanyan, Anza, Parker, and Turk. This undated view looks west from behind the cemetery. The street that borders the cemetery is Arguello. Anza Street runs up the left side of the photograph. In clear view is the French Hospital (now Kaiser

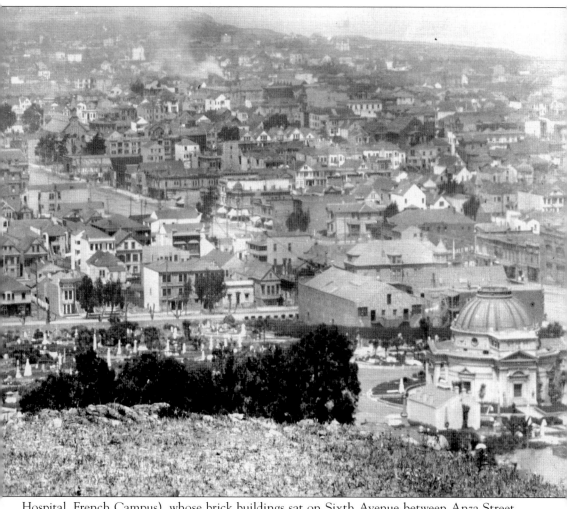

Hospital, French Campus), whose brick buildings sat on Sixth Avenue between Anza Street and Geary. The cemetery's Columbarium is on the right. After the cemetery closed, some of the Richmond streets created were Almaden, Loraine, and Rossi. (Courtesy of a private collector.)

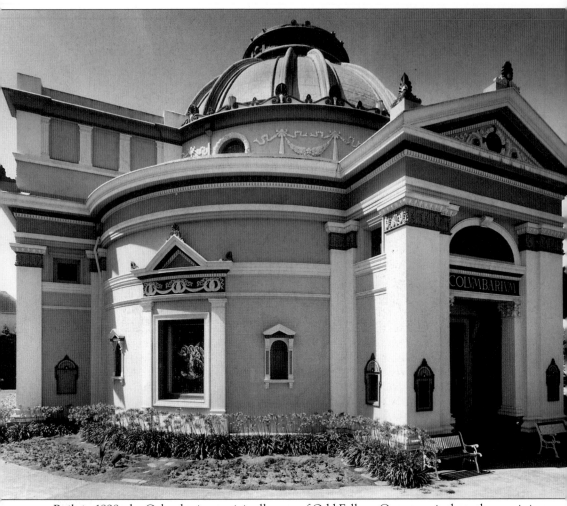

Built in 1898, the Columbarium, originally part of Odd Fellows Cemetery, is the only remaining structure from the Richmond District cemeteries. Home to the cremated remains of thousands of former citizens, the Columbarium was designed by architect Bernard J. S. Cahill. It was declared City Landmark No. 209 on March 3, 1996. (Courtesy of the Neptune Society.)

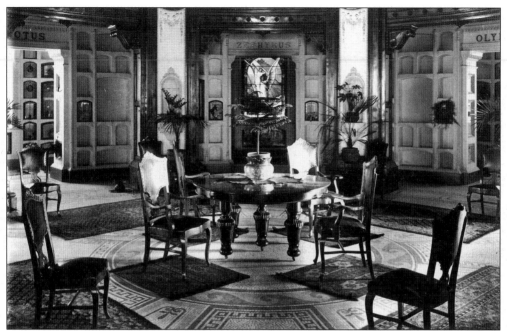

This early interior photograph of the Columbarium shows the niches that hold people's remains and memorabilia. The building features four floors of niches. In this early photograph, most of the niches are unused, but today they are almost entirely full. The Columbarium was neglected for many years, until the Neptune Society bought it in 1980 and restored it. Emmitt Watson, who has played a major role in the restoration and maintenance of the Columbarium, gives regular tours to visitors. (Courtesy of Glenn Koch.)

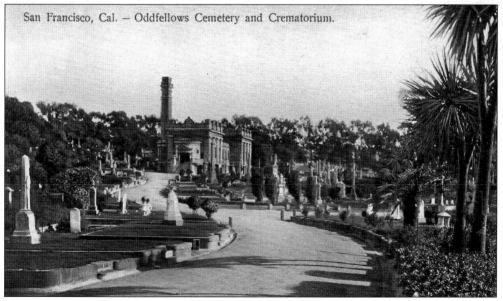

San Francisco, Cal. — Oddfellows Cemetery and Crematorium.

The crematorium (building with the tower) in Odd Fellows Cemetery cremated the remains that were then placed in the Columbarium and in cemetery graves. Rossi Playground, named after Angelo Rossi, a San Francisco mayor from 1931 to 1944, now sits on the former site of the crematorium. (Courtesy of Glenn Koch.)

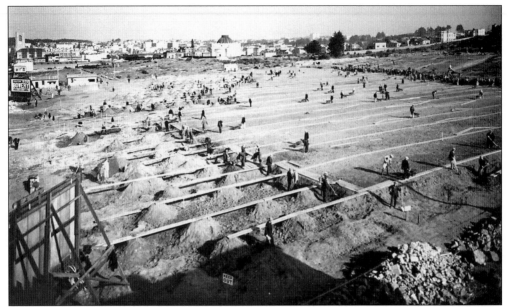

The removal of the bodies from Odd Fellows Cemetery began in 1929 and became a local scandal when two Odd Fellows members collecting funds to purchase burial sites in Colma disappeared with the money. The remains were reburied in a mass grave that sits in one corner of Greenlawn Cemetery. In this photograph, taken on December 26, 1933, men are working to remove bodies in the area that would later become Rossi Playground. (Courtesy of a private collector.)

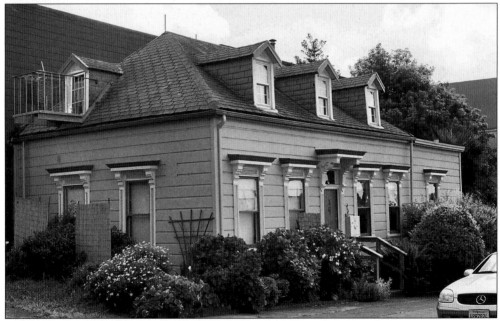

This house at 1 Edward Street, just outside the boundary of Odd Fellows Cemetery, stands out among its neighboring 1930s and 1940s homes. According to *Here Today: San Francisco's Architectural Heritage* (1968), "This cottage is said to have been the caretaker's lodge for Odd Fellows Cemetery. When the cemetery was removed, the small frame house was moved a short distance to its present location." (Photograph by Lorri Ungaretti.)

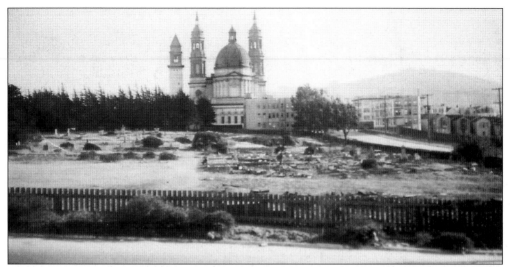

Founded in 1864, Masonic Cemetery sat on 30 acres bounded by Turk, Fulton, Parker, and Masonic Streets. The cemetery sat just behind St. Ignatius Church, seen in this photograph. The most famous person buried in this cemetery was Joshua Norton (1819–1880), an eccentric San Franciscan who, in 1859, proclaimed himself Emperor Norton I and Protector of Mexico. He was locally tolerated and somewhat revered. (Courtesy of San Francisco History Center, San Francisco Public Library.)

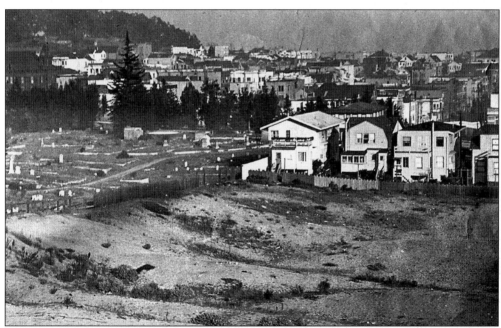

This undated photograph shows homes built up to the Masonic Cemetery property line. Before long, the city would remove all cemeteries to make space for more residential development. Approximately 20,000 remains were moved in the 1930s from Masonic Cemetery to Woodlawn Cemetery in Colma. Some of the streets created after this cemetery closed are Temescal, Chabot, Kittredge, Roselyn, Tamalpais, Annapolis, Loyola, Hemway, and Atalaya. (Courtesy of San Francisco History Center, San Francisco Public Library.)

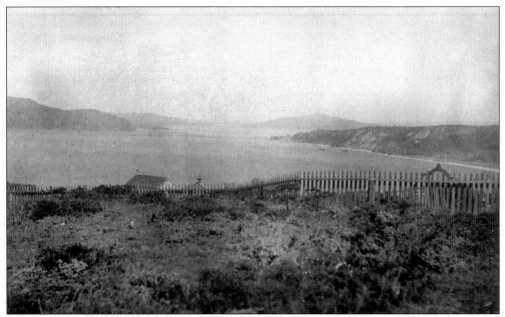

This 1885 photograph looks west toward the ocean from City Cemetery (also called Golden Gate Cemetery). Created in 1868, it housed the remains of the poor and minorities excluded from other cemeteries. In 1893, the city sold 54 acres on the western end of the cemetery to the U.S. Army for a new coastal defense battery, now called Fort Miley. Burials stopped in City Cemetery in 1898. (Courtesy of The Bancroft Library, University of California.)

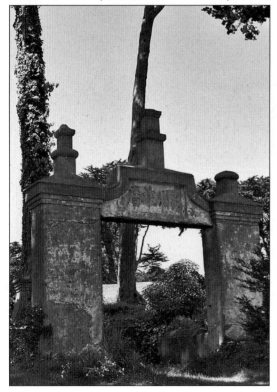

At one time, the eastern end of Laurel Hill Cemetery was the site of a Chinese cemetery. In 1872, these remains were exhumed and reburied in City Cemetery. This Chinese monument stands on the Lincoln Park Golf Course, a reminder of the land's earlier use. (Photograph by Lorri Ungaretti.)

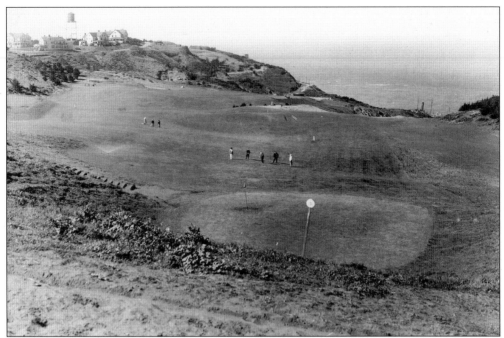

In 1909, the city hired workers to remove the graves and remains from City Cemetery so that the land could become a park. The workers removed the gravestones and cemetery markers, but left many bodies where they lay. Lincoln Park now stands on top of the old cemetery. This photograph shows the early days of Lincoln Park Golf Course. Fort Miley sits at the top left and remains from shipwrecks can be seen at the right. (Courtesy of Emiliano Echeverria.)

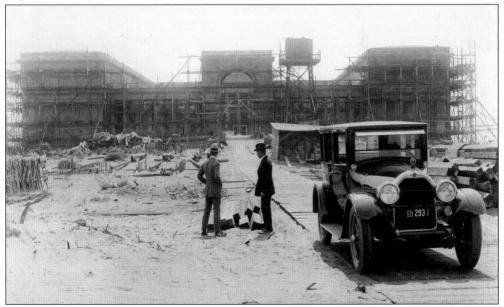

In 1922, the city began work on a museum in Lincoln Park. Designed by architects Edward Larrabee Barnes and Mark Robert Cavagnero, the California Palace of the Legion of Honor is a magnificent museum dedicated to European art. It was funded by Adolph Spreckels and championed by his wife, Alma. (Courtesy of Emiliano Echeverria.)

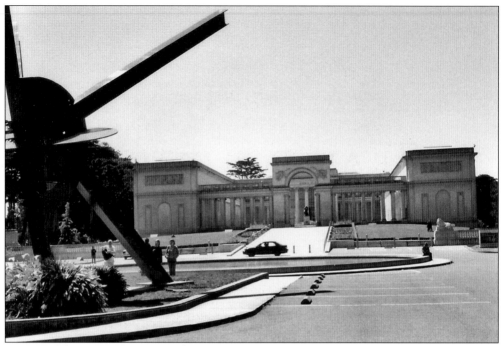

The grounds surrounding the California Palace of the Legion of Honor now include a Holocaust memorial; a monument to the first Japanese naval ship, *Kanrin Maru,* which was in San Francisco Bay on March 17, 1860; and a modern metal sculpture (at left), *pax Jerusalemme* (1999), by Mark di Suvero. (Photograph by Lorri Ungaretti.)

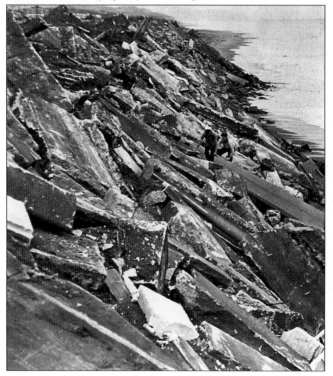

Many remains in the five cemeteries went unclaimed by the families of the dead. The city removed the gravestones and used them as ocean seawalls, as in this picture at Ocean Beach. Parts of former gravestones were also dumped at Aquatic Park, St. Francis Yacht Club (the Wave Organ), and Buena Vista Park. (Courtesy of San Francisco History Center, San Francisco Public Library.)

Three

TRANSPORTATION

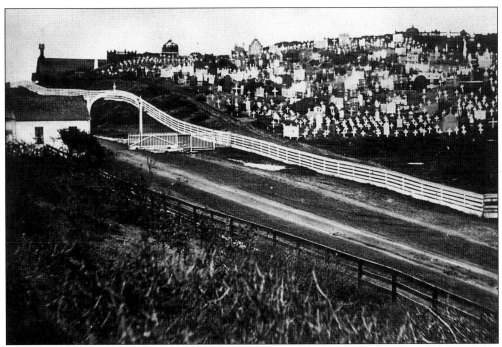

The Point Lobos Toll Road opened in 1865 and ran from what is now Geary and Presidio west to the beach. Toll gates stood at Central (now Presidio) Avenue, Sixth Avenue, and the beach. The toll road, privately maintained until 1877, was purchased by the state, turned over to the city, and became a public thoroughfare. This view of the Central Avenue tollgate shows a cemetery in the background. (Courtesy of a private collector.)

From 1865 to 1879, only horse-drawn carriages and "public" horse-drawn omnibuses drove along the Point Lobos Toll Road because the western terminus of all public rail transportation was Central (now Presidio) Avenue. After 1879, steam trains ran on the north side of the toll road, separated by a fence from the horses. In 1880, a cable car connected with the steam line. Point Lobos Toll Road later became Geary. (Courtesy of a private collector.)

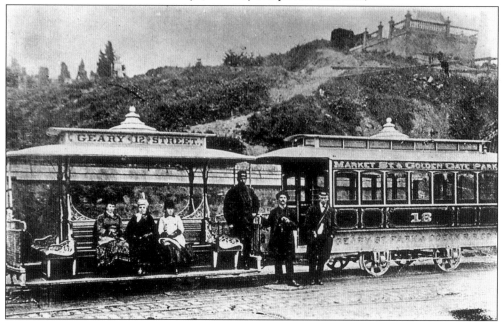

In 1892, cable car service was extended from Market Street and Geary to Golden Gate Park via Point Lobos Road and Fifth Avenue. This 1895 photograph shows one of these cars with Calvary Cemetery behind it. (Courtesy of The Bancroft Library, University of California.)

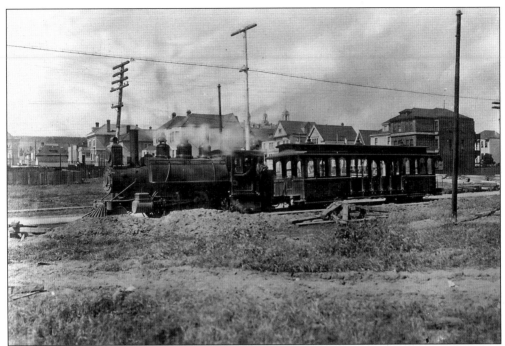

From 1888 to 1906, Adolph Sutro's railway company ran a steam train from California and Central (now Presidio) Avenue to a terminus above Point Lobos. An additional steam train line turned on Seventh Avenue, then ran to D (now Fulton) Street at Golden Gate Park. The 1890 shelter still stands today as the "Powell St. RR Co. Park Entrance." (Courtesy of Virginia Cornyn.)

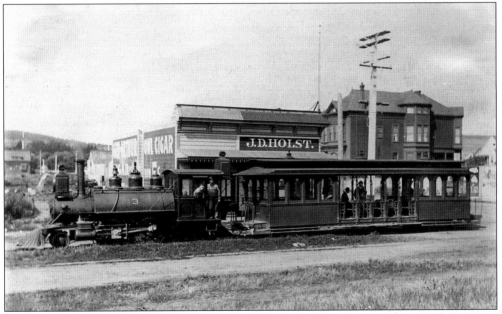

This picture of the Cliff House steam train was taken at Thirteenth (now Funston) Avenue and California Street in April 1905. This train ran along the cliffs out to Adolph Sutro's Cliff House and Sutro Baths (see page 68). Steam trains stopped running in the Richmond District on April 17, 1905. (Courtesy of a private collector.)

43

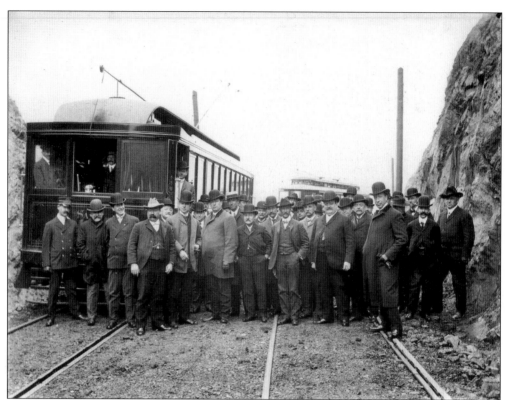

On May 26, 1905, a new streetcar line opened to replace the abandoned steam line around Land's End. Pictured here are some of the celebrants at the opening of the new line. Included were officers of the United Railroads and representatives of Richmond District community groups. (Courtesy of Emiliano Echeverria.)

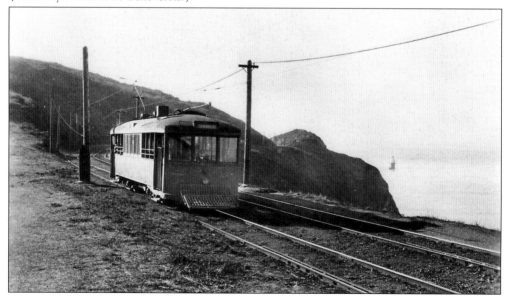

The No. 1 line streetcar followed the same route as the steam train, giving riders breathtaking views of the ocean along the private right-of-way to Sutro's. (Courtesy of Emiliano Echeverria.)

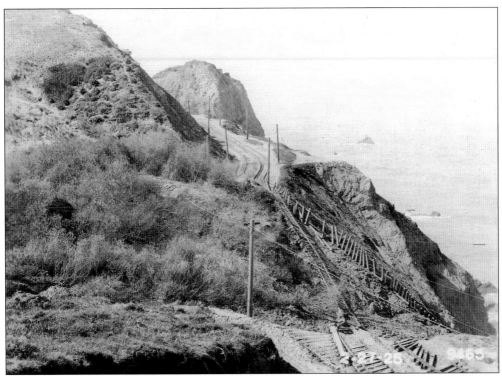

The popular Land's End portion of the No. 1 line route was discontinued after the unstable land washed out in a storm in February 1925. (Courtesy of Emiliano Echeverria.)

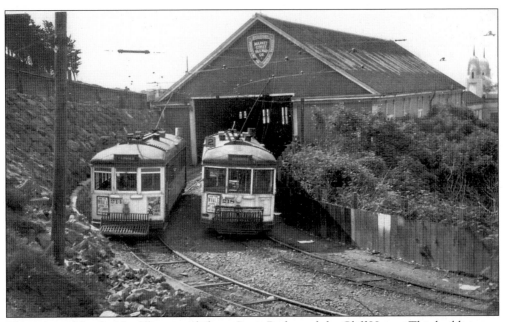

The terminal for the No. 2 line stood above Sutro Baths and the Cliff House. This building was destroyed by fire on February 12, 1949. Note at the far right the two Sutro Baths towers, created during the 1937 remodel. (Courtesy of Emiliano Echeverria.)

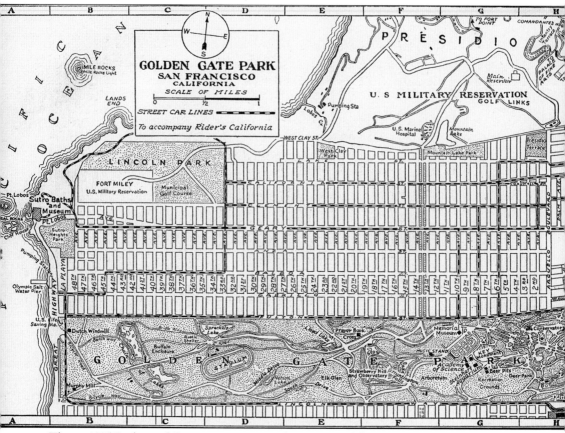

This c. 1925 Richmond District transit map shows most of the streetcar lines that ran through the area before the 1930s. While it shows the original Land's End line, it also shows the later route to Sutro Baths, used after the landslide. (Courtesy of Mark Adams.)

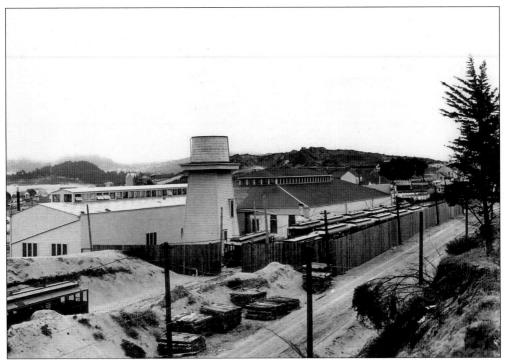

Opened in 1896 to house Sutro Railway Company's streetcars, the Sutro Car House stood on the block bounded by California Street, Clement Street, Thirty-second Avenue, and Thirty-third Avenue. Taken on June 27, 1907, this photograph looks southeast. An Albertson's Super Market occupies that spot today. (Courtesy of Emiliano Echeverria.)

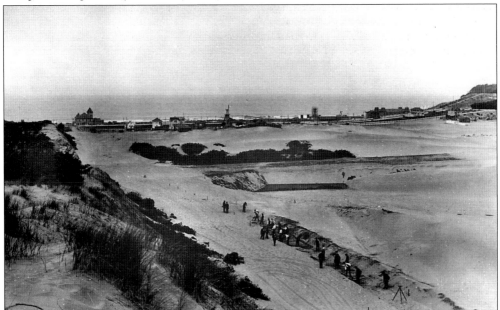

On May 18, 1909, the United Railroads construction crew worked on extending the Fulton streetcar line to the ocean. Sand dunes dominated the area, and the original Beach Chalet still stood along the Great Highway at the end of Fulton Street. (Courtesy of a private collector.)

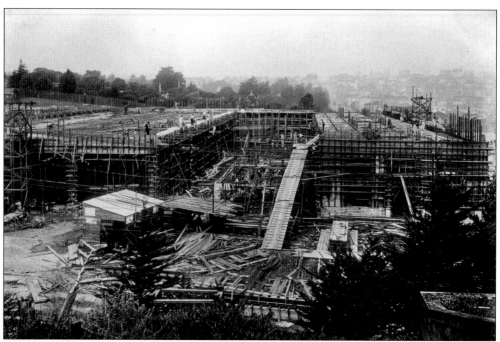

The Geary Street Car Barn still stands today at Masonic and Presidio Avenue, although it faces an uncertain future. Behind this 1912 photograph of the construction is Laurel Hill Cemetery (note the monuments). Presidio Avenue runs to the right of the cemetery; a No. 3 Jackson streetcar is climbing the hill. (Courtesy of a private collector.)

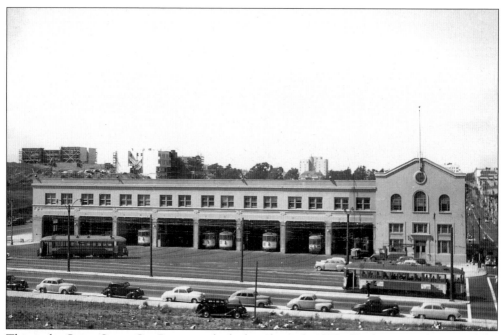

This is the Geary Street Car Barn as it looked in the early 1950s. By this time, the rear of the property, carved from part of the former Laurel Hill Cemetery, had become the "Presidio Division Trolley Coach Base." (Courtesy of Jack Tillmany.)

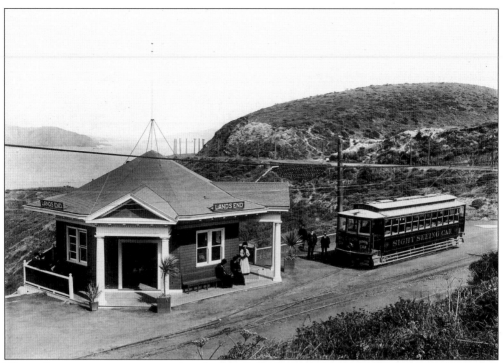

This sightseeing streetcar approaches the Land's End station, built in 1905. Sightseeing cars ran from 1901 to 1918 and were a popular way for people to see the city. This station was leased to concessionaires between 1905 and 1937. (Courtesy of Emiliano Echeverria.)

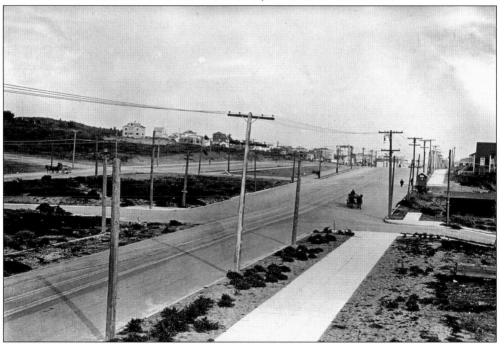

In 1917, lone horse carriages roamed the Richmond near Geary and Forty-third Avenue, and streetcar tracks ran on Geary. (Courtesy of a private collector.)

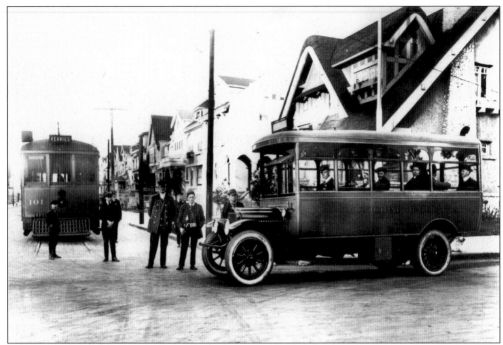

In 1917, two transportation lines met at Tenth Avenue and Fulton Street. Riders wishing to cross Golden Gate Park were forced to take the A car (left), then transfer to the No. 1 Park bus (right) because park superintendent John McLaren would not allow streetcar tracks to be constructed inside the park. (Photograph by Public Utilities Commission; courtesy of Jack Tillmany.)

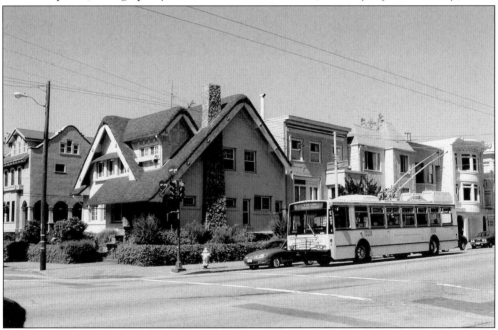

Today the No. 5 Fulton bus runs along Fulton Street to the beach. Behind the bus, as in the photograph above, sits 798 Tenth Avenue, the house built by prominent homebuilder Fernando Nelson. It was inspired by his home at 30 Presidio Terrace. (Photograph by Lorri Ungaretti.)

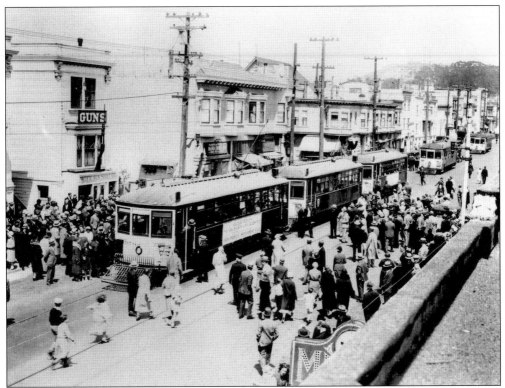

Pictured here is opening day of the No. 31 Balboa streetcar line in 1932, shot from Sixth Avenue and Balboa Street. The No. 31 was the last streetcar line opened in the city. On May 16, 1944, San Franciscans voted to buy the Market Street Railway, which merged with the Municipal Railway to form one organization. In the Richmond, the B and C lines became the No. 38 Geary bus; the numbered lines retained their numbers in the new bus system. (Courtesy of Jack Tillmany.)

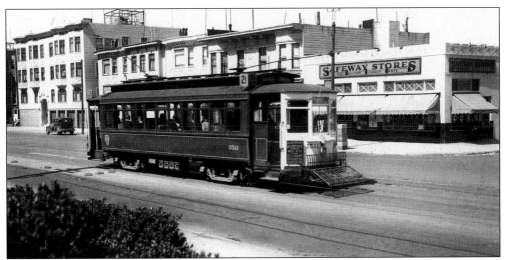

In 1938, the No. 21 line streetcar ran along Fulton Street at Fifth Avenue. The early Safeway store sign in the background sported the slogan, "Distribution without Waste." (Courtesy of Jack Tillmany.)

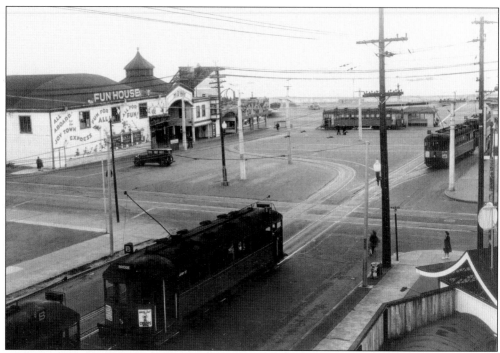

People rode streetcars to get to Playland-at-the-Beach (see page 80). This 1940 photograph shows the turnaround at the Great Highway, known as the Ocean Beach Loop. The B line ended here, then turned around for its trip downtown. The B car ran along Geary and later became the No. 38 Geary bus. These Muni streetcars were known as "battleships" because of their gray color. (Courtesy of Jack Tillmany.)

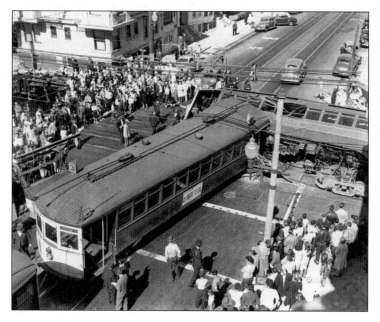

In 1947, a No. 31 car heading east on Balboa ran into a No. 21 car heading north on Eighth Avenue. Jack Tillmany, then ten years old, happily recalls that, as a rider in the front section of the ill-fated Balboa car, he "achieved not only instantaneous nirvana but the lifelong envy of other railfans who were never blessed by having the opportunity to participate in such a memorable event." (Courtesy of Jack Tillmany.)

As people began buying and using cars, roads were widened and changed. This January 1923 view looking north from California between Thirteenth (now Funston) and Fourteenth Avenues, shows the area originally called the "Park Panhandle." The Marine Hospital stands in the distance. (Courtesy of The Bancroft Library, University of California.)

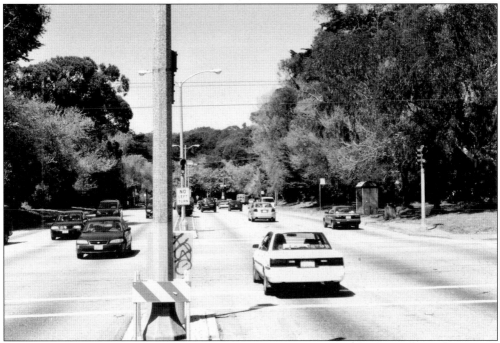

In 1939, the city redesigned and paved the Park Panhandle and renamed it Park Presidio Boulevard. Today this major thoroughfare provides a direct route to the Golden Gate Bridge. (Photograph by Lorri Ungaretti.)

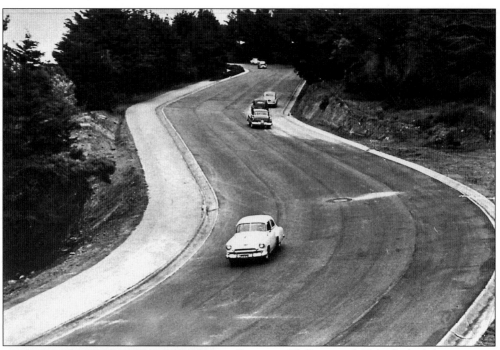

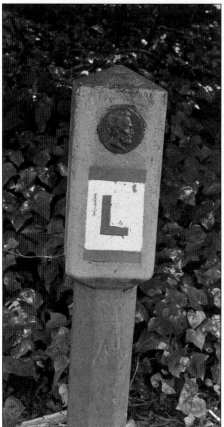

For years, El Camino del Mar linked the California Palace of the Legion of Honor with the area above the Cliff House. However, the road was built on unstable ground and was often partially washed out by winter storms. This view, taken in 1951, accompanied newspaper copy that read, "El Camino del Mar . . . is back in duty . . . The road has long been closed by slides, but now installation of a new drainage system, plus repair work costing $120,000, has readied it for use again." The repair was temporary; the road closed permanently in the late 1950s. (Courtesy of San Francisco History Center, San Francisco Public Library.)

In 1912, Carl Fisher, owner of the Indianapolis Motor Speedway, proposed building the "Coast-to-Coast Rock Highway," the first intercontinental highway. He asked for donations from car companies, local communities, and individuals ($5 each). On July 1, 1913, the road was renamed the Lincoln Highway. Finally completed in 1927, the highway started in New York and ended in Lincoln Park in San Francisco. This photograph shows the marker on California Street at Park Presidio Boulevard. The circle at the top with Lincoln's head says, "This highway dedicated to Abraham Lincoln." (Photograph by Lorri Ungaretti.)

Four

THE CITY'S PLAYGROUND

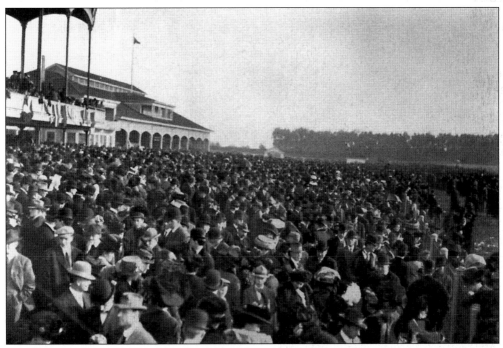

On August 5, 1873, the *San Francisco Chronicle* reported that a horse racing track was needed that would have "accessibility to the various street railroads and avenues for driving, shelter from the winds, and so located as to be out of the line of street improvements." The Bay District Race Track was built just south of Point Lobos Avenue (now Geary) to D (now Fulton) Street, between First Avenue (now Arguello) and Fifth Avenue. The racetrack opened on September 7, 1874. (Courtesy of a private collector.)

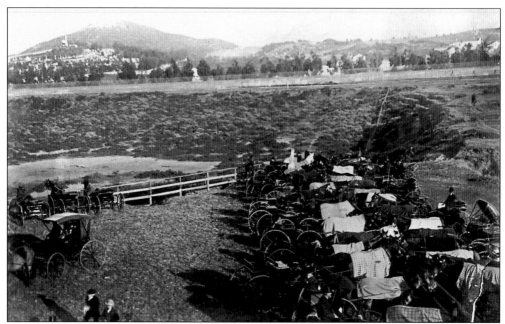

Horses wait for the next race at the Bay District Race Track. In this photograph, the Odd Fellows Cemetery and Lone Mountain are visible in the background, looking east. (Courtesy of a private collector.)

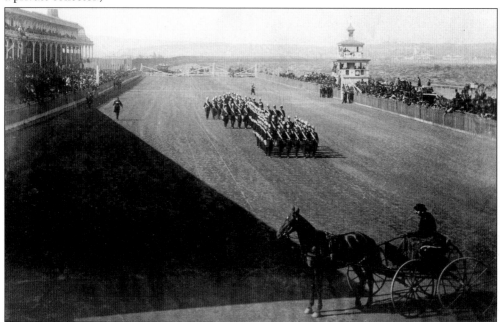

The "Grand Competitive Prize Drill" was held on August 25, 1883, at the Bay District Race Track. By 1895, Richmond residents were arguing for the razing of the track. They wanted streets cut through and developed, and they complained about the bad smells emanating from the track and stables. The last race at the Bay District Race Track was on May 27, 1896. In 1898, military troops came from around the country to use the site, then called "Camp Merritt" (see page 12). The streets were cut through for residential development in late 1898. (Courtesy of a private collector.)

In 1902, Stanford and UC Berkeley needed a new park in which to play the "Big Game," and a square block in the Richmond District was chosen. It was bounded by Lake Street, Seventh Avenue, California Street, and Eighth Avenue. Local residents objected to the grounds being built in their area, and a compromise was reached: the Richmond Grounds were built and used for only two years, 1902–1903. (Courtesy of Angus MacFarlane.)

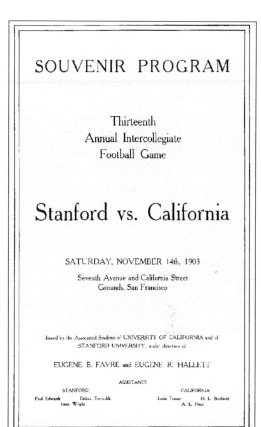

SOUVENIR PROGRAM

Thirteenth
Annual Intercollegiate
Football Game

Stanford vs. California

SATURDAY, NOVEMBER 14th, 1903

Seventh Avenue and California Street
Grounds, San Francisco

Issued by the Associated Students of UNIVERSITY OF CALIFORNIA and of
STANFORD UNIVERSITY, under direction of

EUGENE B. FAVRE and EUGENE R. HALLETT

ASSISTANTS

STANFORD CALIFORNIA
Paul Edwards Delma Reynolds Leslie Turner H. L. Stoddard
 Irene Wright A. L. Price

In 1902, Cal beat Stanford, 16-0; in 1903, the game was a 6-6 tie. This chart shows seating and ticket prices for the 1903 Big Game. The players' names appear in the middle. Dismantling of the Richmond Grounds began as soon as the 1903 game ended. (Courtesy of Angus MacFarlane.)

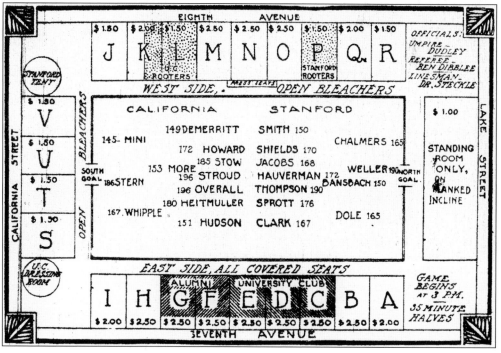

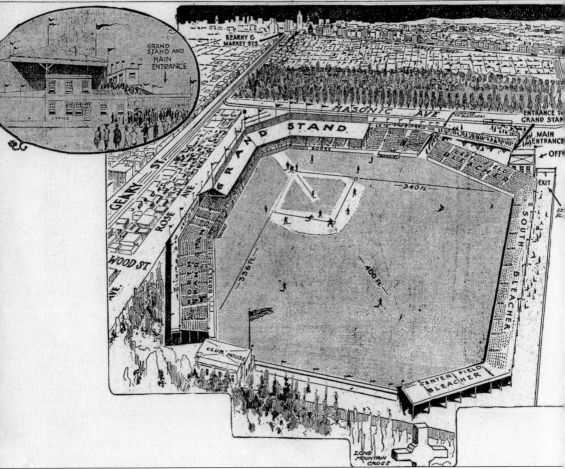

In 1913, J. Cal Ewing, owner of the San Francisco Seals baseball team, leased land owned by the Catholic Archdiocese at the foot of Lone Mountain, just west of Calvary Cemetery (see page 30). The new field was being touted as the home of the Seals for the next twenty years. On February 22, 1914, the *San Francisco Chronicle* wrote, "The only possible drawback to the new location is the possibility of meeting with bad weather conditions . . . wind and fog may be experienced in the afternoons. The advantage of an up-to-date park, however, will do much to balance against those handicaps." The newspaper's optimism was not realistic. (Courtesy of Angus MacFarlane.)

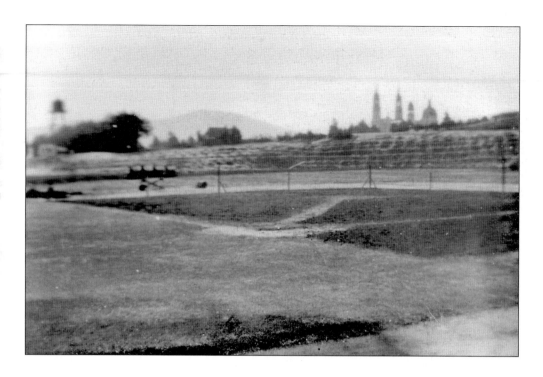

These two images of Ewing Field were taken by William Bunting during construction in 1914. At the time, people called it "Seals Park" in the expectation that the team would play there for a long time. (They played there for only one season.) In the top photograph, the towers of St. Ignatius Church are clearly part of the view. The bottom photograph shows the construction of the bleachers. (Courtesy of Virginia Cornyn.)

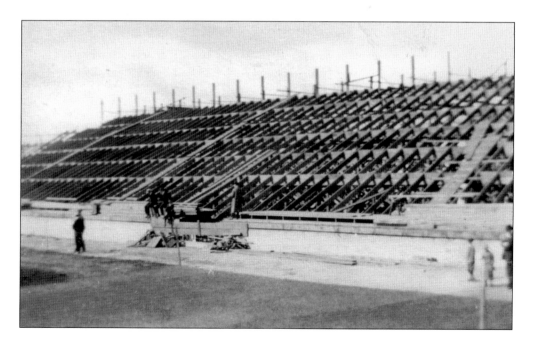

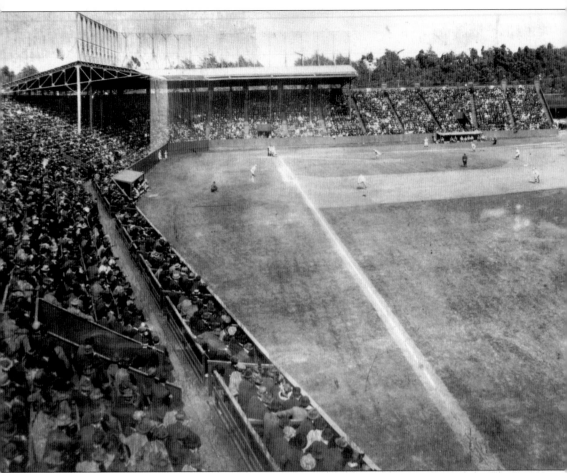

On May 16, 1914, the Seals played their first game at Ewing Field, attracting almost 14,000 fans. One was quoted as saying, "You ought to call it 'icicle field.' " Within a short time, the crowds dwindled, mostly due to the foggy summer weather in the Richmond. On June 7, 1914, the Seals played to a crowd of only about 200, and the *San Francisco Chronicle* wrote, "The field was so slippery there was hardly a chance for the men to steady themselves; the ball so wet that pitching of any quality was impossible; and the track was so heavy that base running was out of the question." (Courtesy of California Historical Society, FN-40049.)

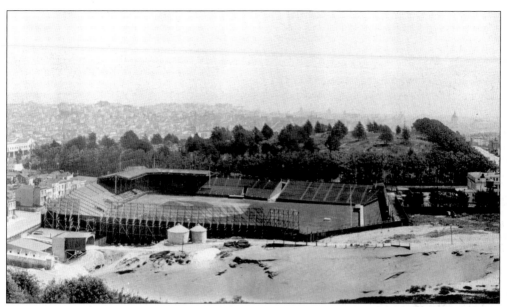

On June 6, just three weeks after Ewing Field opened, a game was canceled due to fog. Ewing sold the Seals at the end of the season, and the team stopped playing in Ewing Field, by then considered a "white elephant." This 1915 view looking toward downtown shows undeveloped dunes in the foreground and Calvary Cemetery (see page 30) directly behind the field. (Courtesy of a private collector.)

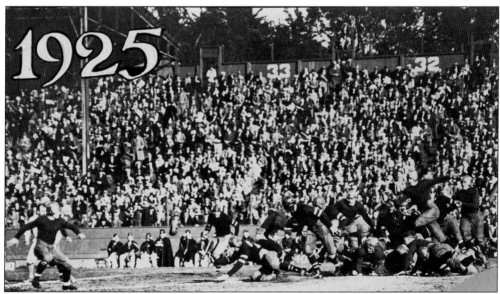

Ewing Field hosted other events over the years. The first East-West Shriners game was played there in 1925. (The West won, 6-0.) On June 5, 1926, a fire damaged the field and destroyed many nearby homes. In 1938, the field was sold and demolished for residential development. (Courtesy of San Francisco History Center, San Francisco Public Library.)

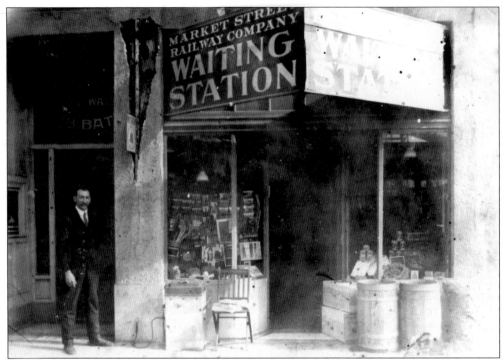

Some of the Richmond District's attractions were hotels and roadhouses where people could engage in "sinful" activities far from the eyes of the city. This undated photograph, taken at approximately Forty-eighth Avenue and Cabrillo, shows M&Ms, which featured drinking, dancing, and "fresh salt water steam baths." It was often raided by police for illicit activity. On the right is the Market Street Railway Company Waiting Station, where people could buy a variety of items as they waited for transportation downtown. (Courtesy of Emiliano Echeverria.)

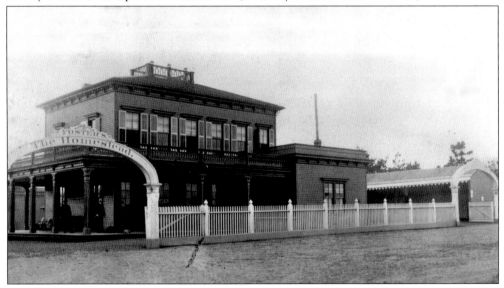

It is difficult to say which establishments were legitimate hotels. Perhaps the elegant Foster's The Homestead, which stood on Point Lobos Toll Road near Twenty-fifth Avenue in 1860, was a respectable hotel. (Courtesy of California Historical Society, FN-09540.)

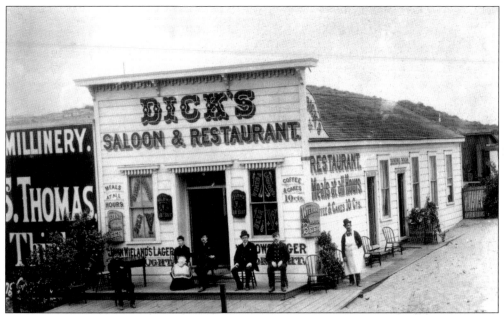

Dick's Saloon and Restaurant stood at Forty-third Avenue and Point Lobos Road. Fort Miley is seen in the background of this 1903 photograph. (Courtesy of a private collector.)

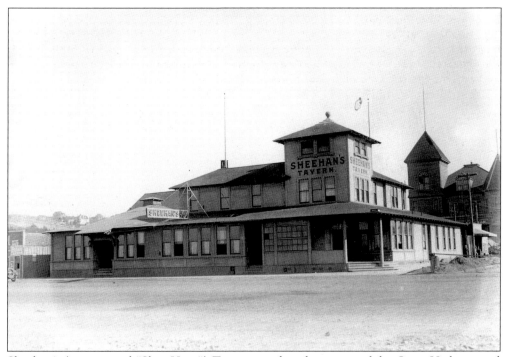

Sheehan's (pronounced "Shee-Hans") Tavern stood at the corner of the Great Highway and Fulton Street. Another popular destination on outer Fulton Street was the Casino, which was originally in Golden Gate Park but moved to Fulton Street near Twenty-fourth Avenue in 1896. Neither building still exists. (Courtesy of Emiliano Echeverria.)

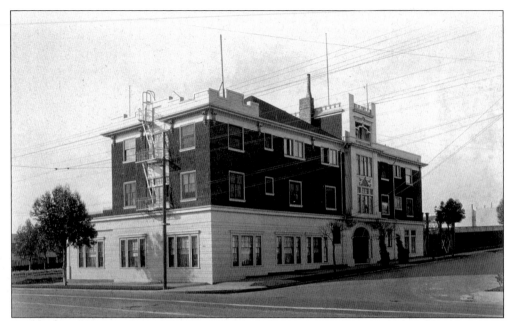

In 1907, Joseph Cairns opened the 50-room Cairns Hotel at 6000 Fulton Street. Cairns envisioned a high-class hotel way out of town, near Golden Gate Park. However, the new automobile redefined "out of town," and people took longer road trips. The last of the roadhouses in the Richmond District, Cairns Hotel stayed in business until it became a sanitarium around 1920. The building has held apartments since 1932. (Courtesy of The Bancroft Library, University of California.)

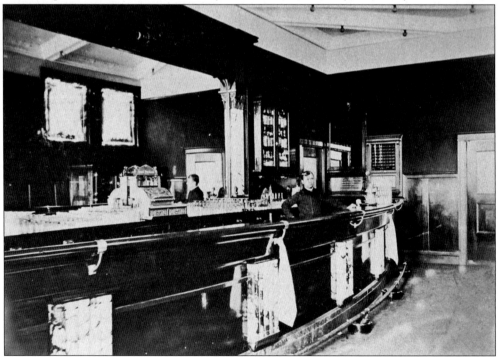

In 1907, C. E. Morgan was behind the bar at the Hotel Cairns. (Courtesy of San Francisco History Center, San Francisco Public Library.)

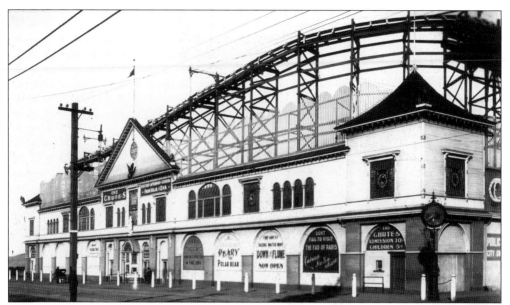

In 1902, the Chutes Amusement Park (not to be confused with Chutes-at-the-Beach, which appeared along the Great Highway in the 1920s) became the first amusement park on the western side of the city when it moved from Haight-Ashbury to the Richmond. Chutes opened on one square block at Fulton and Cabrillo Streets, Tenth and Eleventh Avenues. At the back of this photograph is the "Scenic Railway," which encircled the park and was a precursor to modern roller coasters. The main draw was the Chutes ride (see next page). (Courtesy of Emiliano Echeverria.)

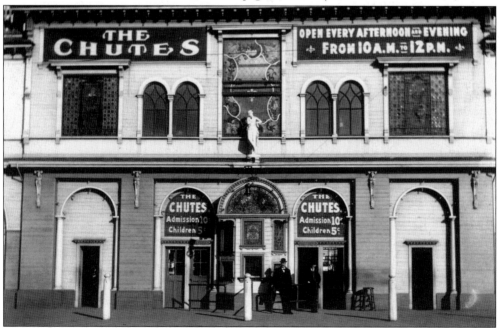

This photograph shows the entrance to the Chutes Amusement Park. For a nickel or a dime, a patron could ride the Chutes or a miniature train, play at shooting galleries, eat at a cafeteria, and more. Chutes had the only zoo in the city at that time. It featured exotic animals, including polar bears, orangutans, monkeys, and a lion. (Courtesy of Emiliano Echeverria.)

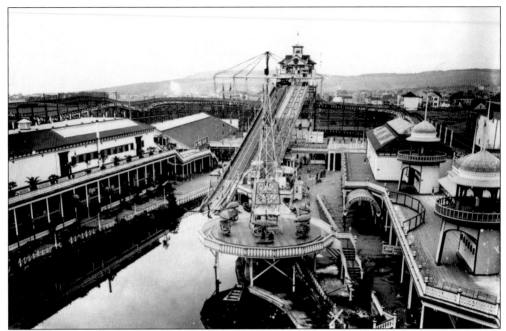

This 1906 photograph shows the attraction after which Chutes Amusement Park was named. The tall structure is the Chutes. Riders rode a gondola up to the top and then came hurtling down, splashing into the water. (Courtesy of Emiliano Echeverria.)

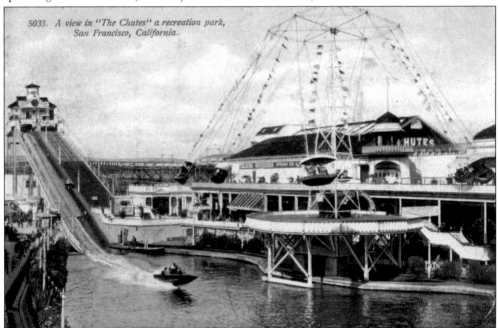

Here is another view of Chutes. The dark building with "CHUTES" written on it was the Chutes Theatre, which sat on Tenth Avenue across from the amusement park. Al Jolson played at the Chutes Theatre, and it was the first venue for the San Francisco Opera when the opera house downtown was destroyed in 1906. At the right is the popular Circle Swing ride. (Courtesy of John Freeman.)

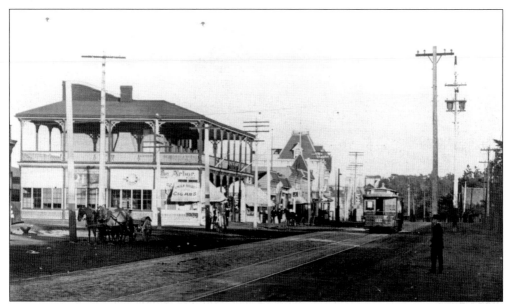

After the opening of the Bay District Race Track and the 1894 Midwinter Fair in Golden Gate Park, and after the 1906 earthquake, roadhouses and saloons sprang up on Fulton Street. Fulton Street between Fifth and Tenth Avenues became known as "Beertown." Scores of establishments included El Portal, Museum Saloon, Old Nuremberg, Bay District Pavilion, Richmond Hotel and Bar, and a branch of Little Shamrock, whose original pub still exists south of Golden Gate Park. Beertown began to fail as Richmond neighborhood groups called it "unwholesome" and lobbied hard from 1907 to 1912 to close down the businesses. (Courtesy of a private collector.)

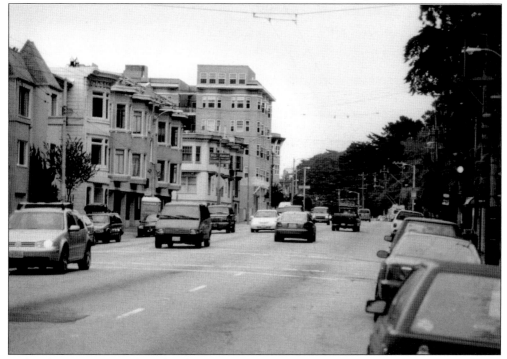

Today there is no sign left of the old Beertown on Fulton Street. (Photograph by Peter Field.)

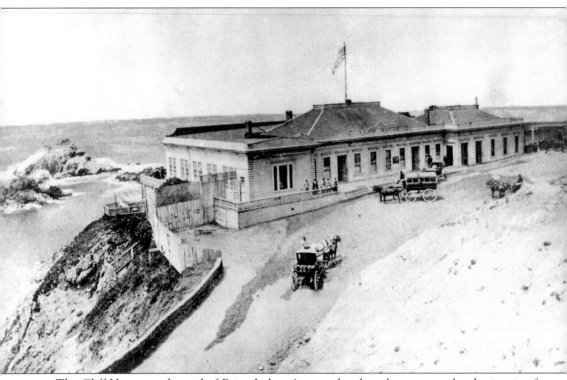

The Cliff House, at the end of Point Lobos Avenue, has long been a popular destination for tourists. There have been three Cliff Houses and various remodels. This postcard shows the first Cliff House, which opened on October 15, 1863. Mark Twain wrote about a visit to the Cliff House, although he focused on the trip from downtown: "The wind was cold and benumbing, and blew with such force that we could hardly make headway against it. It came straight from the ocean, and I think there are icebergs out there somewhere. True, there was not much dust, because the gale blew it all to Oregon in two minutes." Adolph Sutro bought the Cliff House in 1883, and the building was destroyed by fire on December 25, 1894. (Courtesy of Pacific Gas and Electric Company.)

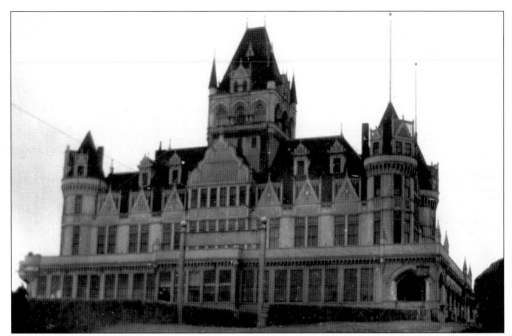

Adolph Sutro built the magnificent second Cliff House in 1896. Fashioned after a French chateau, the new Cliff House looked like a hotel, but it was always a restaurant—with many private rooms. It was eight stories tall and had a 200-foot-high observation tower. (Courtesy of Emiliano Echeverria.)

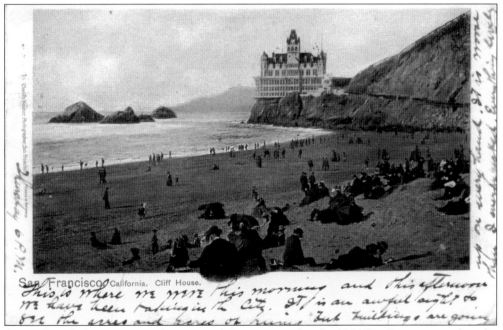

An unidentified visitor wrote this postcard about a year after the 1906 San Francisco earthquake and fire: "This is where we were this morning, and this afternoon we have been taking in the City. It is an awful sight to see the acres and acres of ruins, but buildings are going up on every hand." (Courtesy of Mark Adams.)

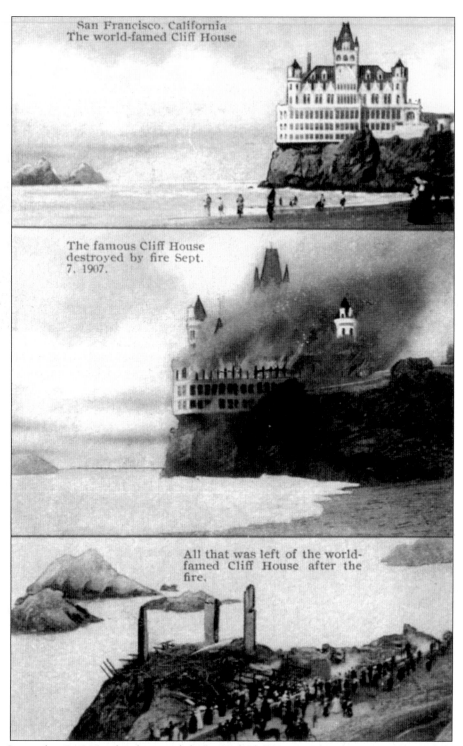

San Francisco. California
The world-famed Cliff House

The famous Cliff House
destroyed by fire Sept.
7, 1907.

All that was left of the world-
famed Cliff House after the
fire.

On September 7, 1907, a fire destroyed the second Cliff House. This three-part postcard showed the devastation. As people watched, firefighters continued to pour water on the ashes. (Courtesy of Mark Adams.)

The third Cliff House, built by daughter Emma Sutro (Adolph Sutro had died in 1898), opened on July 1, 1909. It was designed by the Merritt Brothers, who later created the New Balboa Theatre (see page 127). This picture was taken in 1920. (Photograph by Randolph Brant; courtesy of Emiliano Echeverria.)

The Cliff House Road, built in the 1860s and shown here during the c. 1910 rebuilding, connected the Great Highway and beach areas to Point Lobos Avenue. (Courtesy of Emiliano Echeverria.)

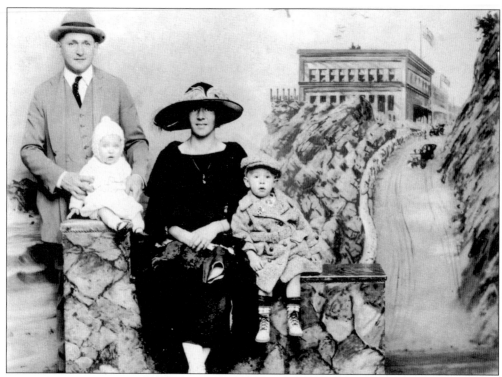

Fritz and Roesel Messer posed for this *c.* 1925 portrait with their sons Herbert and Ben. The backdrop is the third Cliff House, where Fritz later worked as maitre d'. (Courtesy of Dorothy Cox.)

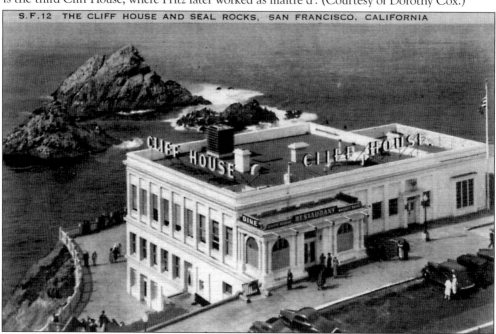

The Sutro family sold the Cliff House to Charles Whitney Sr. in 1937. Exterior remodeling included placing neon lights on the roof and removing the awning at the entrance. (Courtesy of Mark Adams.)

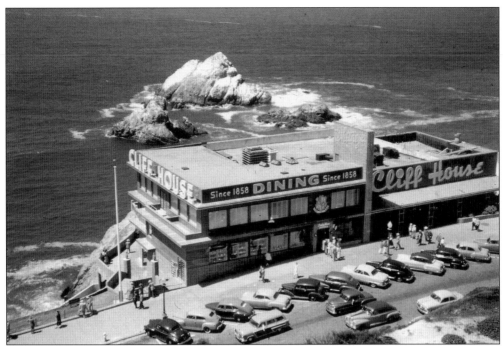

The Cliff House was remodeled again in the late 1940s. This picture was taken in 1952. The U.S. Park Service acquired the Cliff House in 1977 and in 2002 began restoring the building. The restaurant reopened in 2005. (Photograph by Andrew J. Brandi.)

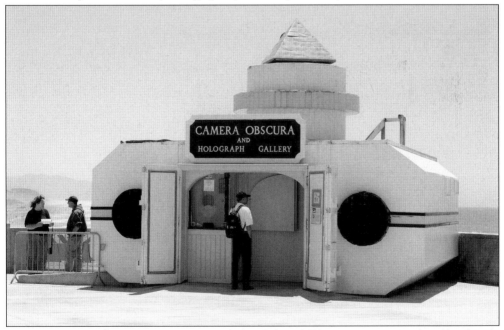

Built in 1946, the Camera Obscura stands behind the Cliff House. A registered city landmark, it features a coated mirror that reflects the scene outside. Visitors stand inside a dark room and watch the image on a large concave disk. The origin of the Camera Obscura has been traced to drawings by Leonardo da Vinci. (Photograph by Tom Vincent.)

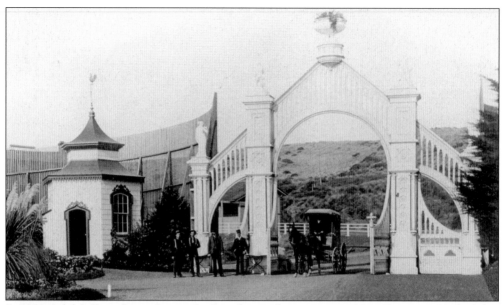

In 1881, Adolph Sutro began buying land in the northwest corner of San Francisco. He built his own home on approximately 20 acres at the end of Point Lobos Road and, in 1885, opened the area to the public so others could enjoy his grounds, gardens, and statuary. This photograph shows the original entrance to what is called Sutro Heights, now part of the Golden Gate National Recreation Area. (Courtesy of Emiliano Echeverria.)

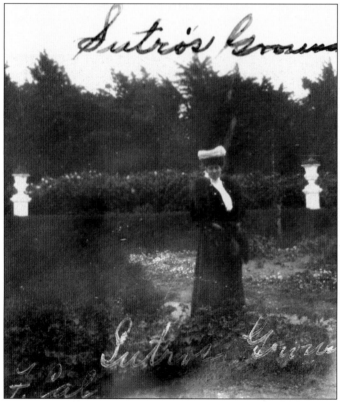

An unidentified woman visits Sutro Heights Park at the end of the 19th century. (Courtesy of Christine Miller.)

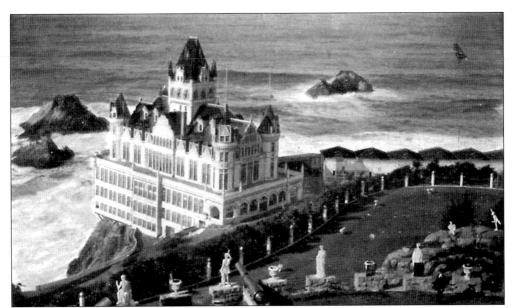

This was Adolph Sutro's view from his house at Sutro Heights. He could see the statuary on his estate, his bold Victorian Cliff House, and the ocean beyond. In 1888, he was quoted in *The Morning Call* newspaper: "I have been around the world several times and visited many places famous for scenery, but I have never seen a finer sight than that which lies before you." (Courtesy of John Freeman.)

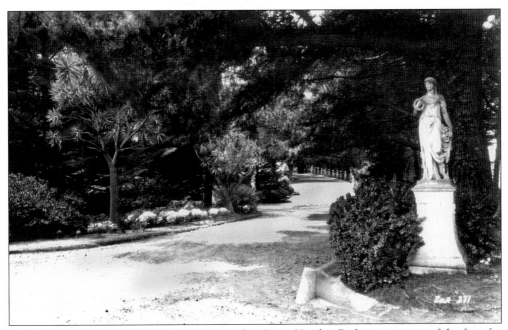

The house is gone, as is most of the statuary, but Sutro Heights Park remains a restful refuge for city residents. (Courtesy of Christine Miller.)

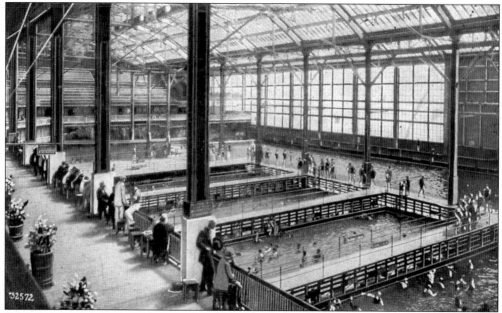

Adolph Sutro was perhaps best known for building Sutro Baths, a collection of seven indoor swimming pools heated to different temperatures. Sutro Baths opened in 1894, although its "official opening" was March 14, 1896. (Courtesy of John Freeman.)

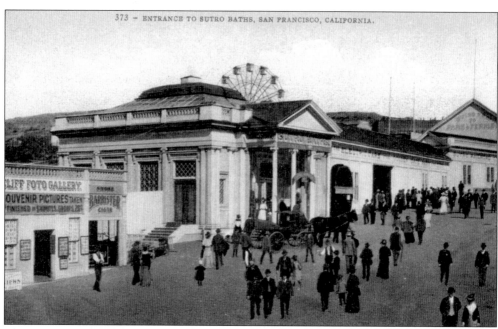

373 – ENTRANCE TO SUTRO BATHS, SAN FRANCISCO, CALIFORNIA.

This postcard shows the entrance to Sutro Baths in the early days, when people traveled by horse and buggy. The Firth Wheel (an early Ferris Wheel) appears in the background. For a short time, Adolph Sutro ran a small amusement park above the baths, on Merrie Way. It had a Firth Wheel, Haunted Swing, and small roller coaster. (Courtesy of John Freeman.)

These unidentified people pose on the grand staircase that led to the Sutro Baths pools. (Courtesy of Emiliano Echeverria.)

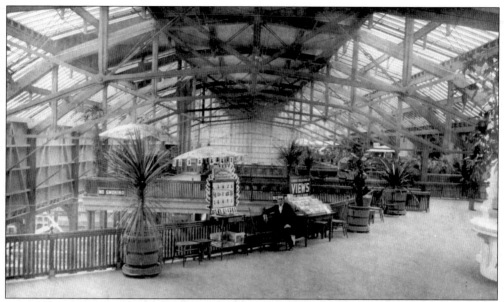

On the promenade, people could view exhibits—stuffed animals, photographs, knights' armor, and other objects—and watch the swimmers (later ice skaters) below. This area was featured prominently in the 1958 film, *The Lineup*. (Courtesy of Emiliano Echeverria.)

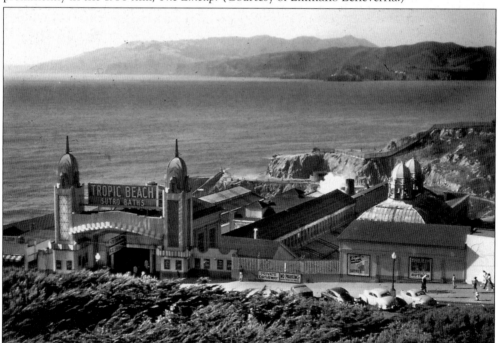

By the 1930s, Sutro Baths was past its heyday and the pools were showing their age. In 1937, Adolph Sutro's grandson remodeled the building and covered some of the pools with an ice skating rink. The exterior was changed significantly and the new sign read, "Tropic Beach–Sutro Baths." In 1952, new owner George Whitney covered the rest of the pools with a large ice skating rink. In this 1952 picture, signs on the building next door advertise the ice skating. (Photograph by Andrew J. Brandi.)

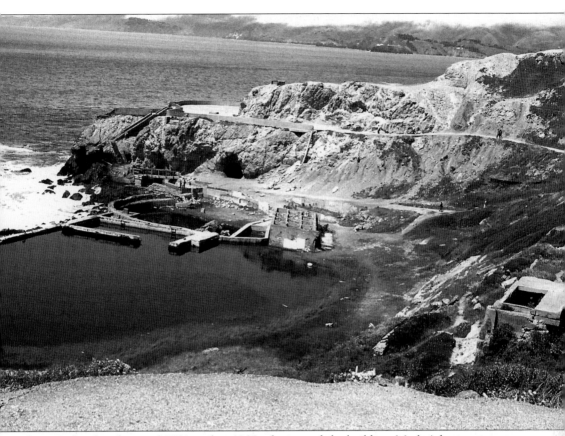

Sutro Baths closed around 1964, and in 1966 a fire gutted the building. Mark Adams was seven years old at the time. "I was playing on the swings at Rossi Park when I saw a mushroom cloud of black smoke. I ran home to our house on Anza and told my aunt that something was going on. We drove her green Studebaker to the Palace of the Legion of Honor. We walked and crawled along the road behind the museum and watched Sutro Baths burn." The ruins are now part of the Golden Gate National Recreation Area, and were featured in the 1972 movie *Harold and Maude*. (Photograph by Lorri Ungaretti.)

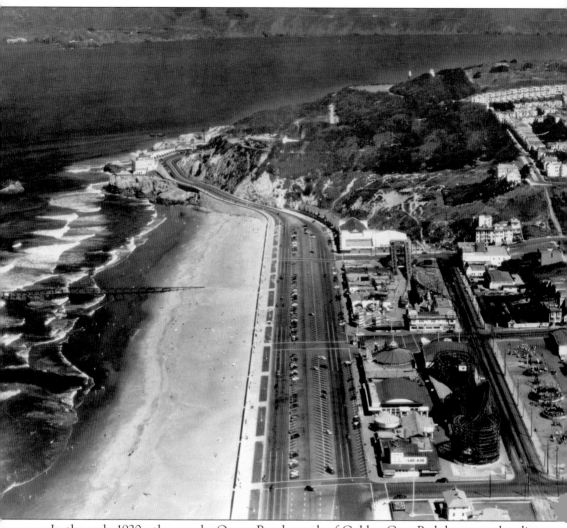

In the early 1920s, the area by Ocean Beach north of Golden Gate Park became a bustling amusement park. (Courtesy of Jack Tillmany.)

In February 1946, groundbreaking for the new Skateland-at-the-Beach included press coverage with photographs of roller-skating star Gloria Nord (with shovel), a member of the Skating Vanities. (Courtesy of Ellie Shattuck.)

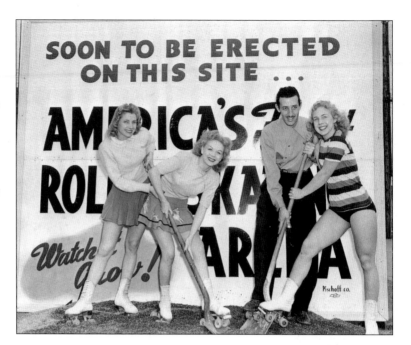

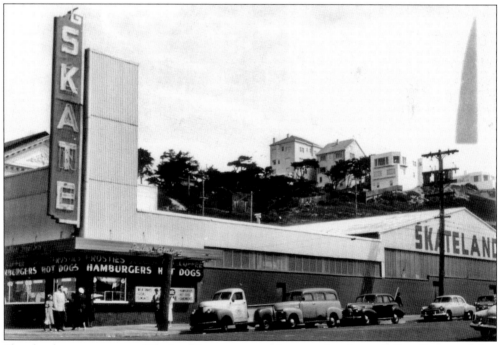

Skateland was not a part of Playland (see next page) but was close by, at Balboa Street and the Great Highway. It opened in 1947 and was run by Meredith ("Red" or "Pop") Shattuck, a well-known roller skater and skating teacher. People could skate at the rink, then go next door and dance at the Edgewater. (Courtesy of Ellie Shattuck.)

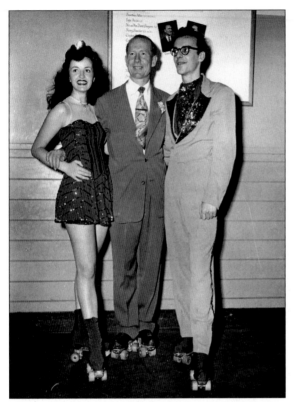

Red Shattuck (center) of Skateland poses with Joan Liuzzi, an award-winning skater, and her partner Clint Drullard. Shattuck traveled extensively to promote roller skating and tried, unsuccessfully, to get it adopted as an event at the Olympics. (Courtesy of Joan Liuzzi.)

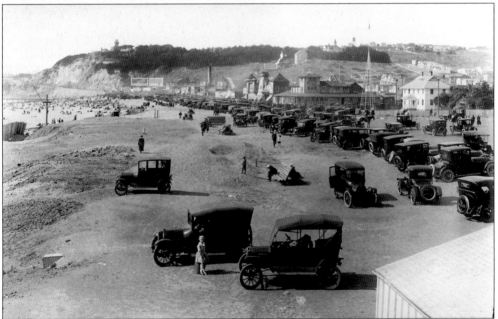

This 1922 photograph shows the area along the Great Highway that featured carnival rides and dancing. Brothers George and Leo Whitney named it "Playland-at-the-Beach" in 1928. For almost 50 years, Playland was a popular destination that featured a midway, rides, concessions, a fun house, a merry-go-round, and more. (Courtesy of Emiliano Echeverria.)

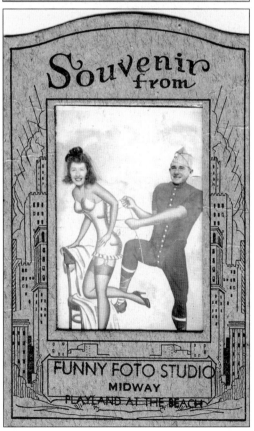

Visitors to Playland and the Cliff House could buy a number of photographic souvenirs. Above: Two men dressed in cowboy outfits stood in front of a backdrop of the Cliff House. (Courtesy of John Freeman.) Below: A man and a woman stood behind a humorous image with just their faces showing. (Courtesy of Dennis O'Rorke.)

Souvenir from

FUNNY FOTO STUDIO
MIDWAY
PLAYLAND AT THE BEACH

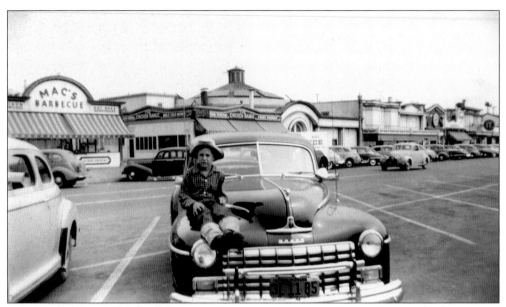

Dennis O'Rorke sat on his father's Dodge in front of Playland c. 1948. Unlike many amusement parks, Playland was open year round. (Courtesy of Dennis O'Rorke.)

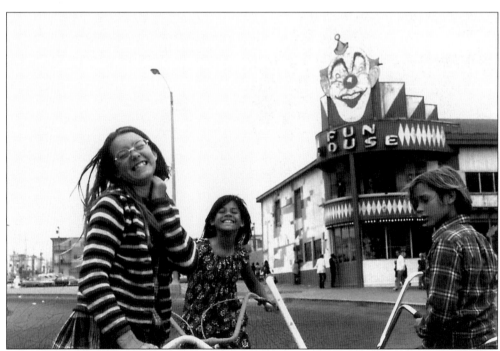

Chelle and Noelle Beloy show off for the camera in front of Playland's Fun House in the early 1970s. (Courtesy of Dennis O'Rorke.)

Children either loved or were frightened by Laughing Sal, the mechanical mannequin with the screeching laugh at the entrance to the Fun House. (Photograph by Shirley Leytem; courtesy of Peggy Vincent.)

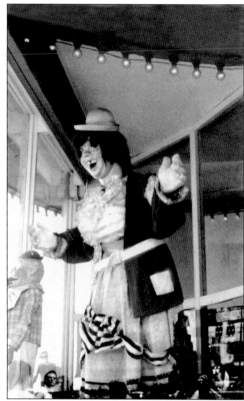

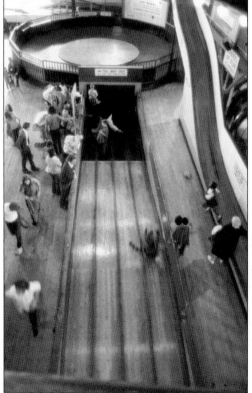

Once inside the Fun House, people could choose from a variety of activities. A popular attraction was the wooden slides. Children walked "forever" up to the top, picked up a piece of burlap sack, and rode down on the sack. This view from above shows the slides as well as another popular ride, a circular disk that spun around throwing the riders off the edge. (Some people called it the "Record Player.") (Courtesy of Dennis O'Rorke.)

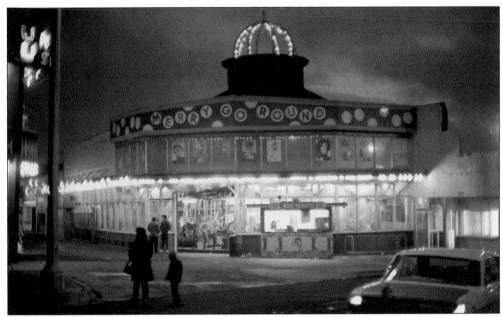

This beautiful nighttime shot shows part of the Fun House (left) and the Playland Merry-Go-Round. The Merry-Go-Round has been restored and is now part of Yerba Buena Gardens, south of Market Street. (Courtesy of Dennis O'Rorke.)

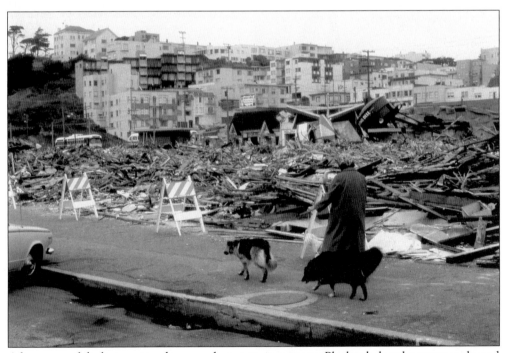

After years of declining attendance and poor maintenance, Playland closed permanently and was razed in 1972. All that remained in this picture was one of the rides, "The Diving Bell." Condominiums now stand on the site. (Courtesy of Dennis O'Rorke.)

Five

CHURCHES, SCHOOLS, AND OTHER PUBLIC BUILDINGS

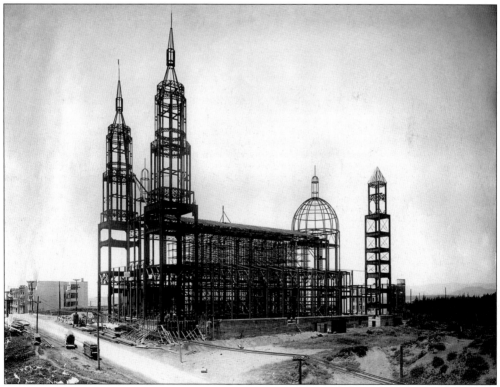

Probably the most recognizable landmark from the Richmond District is St. Ignatius Church, which opened on Fulton Street in 1914. In this photograph, the church is under construction. (Courtesy of California Province of the Society of Jesus Archives, Los Gatos.)

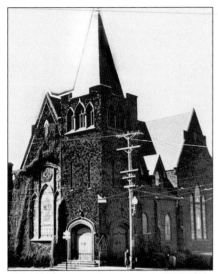

St. John's Presbyterian Church opened at Lake and Arguello on April 15, 1906. Three days later, in the great San Francisco earthquake, the chimney toppled into the church. The church was repaired and rededicated on April 25, 1907. It was declared City Landmark No. 83 on September 12, 1976. (Courtesy of San Francisco History Center, San Francisco Public Library.)

This imposing building at 900 Balboa, now the Chinese Grace Baptist Church, was built in 1911 by well-known developer Joseph Leonard as a residence for Mr. and Mrs. Daniel O'Connell. (Courtesy of John Freeman.)

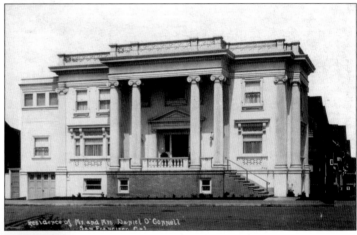

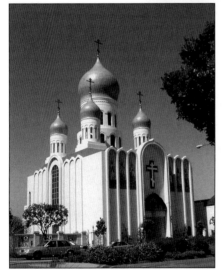

The Holy Virgin Cathedral, with its striking gold domes, was built in 1961 on Geary between Twenty-sixth and Twenty-Seventh Avenues. The congregation began in 1927 with Russian exiles who had fled the Bolshevik Revolution of 1917–1919. (Photograph by Lorri Ungaretti.)

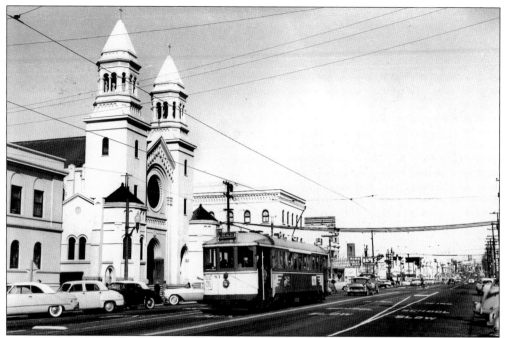

Star of the Sea Parish was a pioneer religious community in the Richmond District starting in 1887. Star of the Sea Church was built in 1916 at Eighth Avenue and Geary. In this 1956 photograph, the B line streetcar passes the church. (Photograph by Walter Vielbaum.)

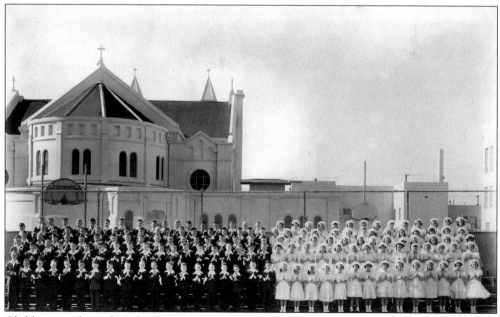

Children are dressed up for their first Holy Communion at Star of the Sea in this early 1950s photograph. (Courtesy of Dennis O'Rorke.)

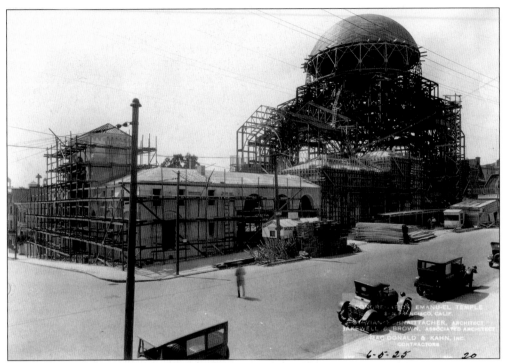

In 1924, construction of Temple Emanu-El began. The building was designed by the architectural team of John Bakewell and Arthur Brown Jr., also known for designing San Francisco City Hall. Consulting architects were Bernard Maybeck (known for the Palace of Fine Arts) and G. Albert Lansburgh (San Francisco Opera House). Temple Emanu-El opened in 1926 and received the American Institute of Architects Distinguished Honor Award in 1927. The synagogue's distinctive dome can be seen from many places throughout the city. (Courtesy of Congregation Emanu-El archives.)

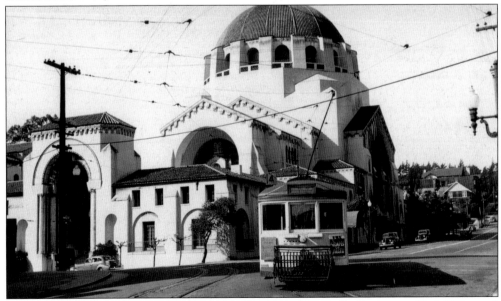

The No. 4 streetcar passes Temple Emanu-El in this 1940 photograph. (Courtesy of Jack Tillmany.)

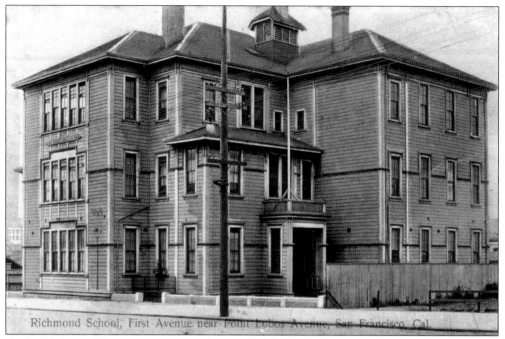

As the Richmond District grew, so did the need for schools to educate children. Richmond School opened in 1888 at what is now Arguello and f. Roosevelt Middle School serves students at that location now. (Courtesy of Mark Adams.)

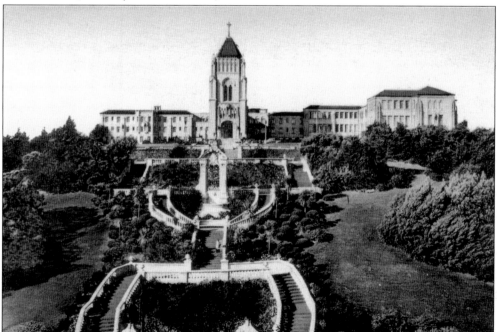

In 1930, the San Francisco College for Women, a Catholic women's college, moved from Menlo Park to Lone Mountain, where ornate stairways led to the new building at the top of the hill. In 1968, the school was renamed Lone Mountain College. Since 1978, the land and buildings have been part of University of San Francisco. (Courtesy of John Freeman.)

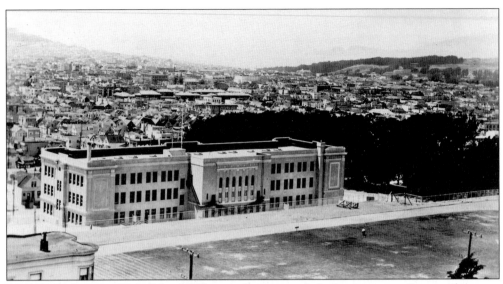

In 1929, St. Ignatius High School (SI) moved to its newly built campus on Stanyan between McAllister and Turk. In this photograph, the trees of Odd Fellows Cemetery (see page 32) appear to the right of the school. Peter Devine's father and uncle often helped clear out the cemetery's broken tombstones. "The Jesuits had students do this to fulfill the state's physical education requirement," writes Paul Totah in *Spiritus 'Magis.'* Some well-known graduates of the Stanyan Street campus were San Francisco Mayor George Moscone (Class of 1947), actor Richard Egan (1935), and California Gov. Jerry Brown (1955). (Courtesy of St. Ignatius College Preparatory.)

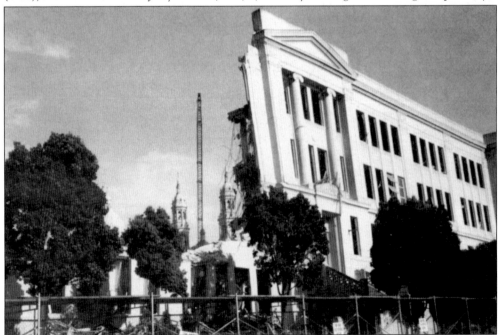

In 1969, SI changed its name to St. Ignatius College Preparatory and moved to new buildings in the Sunset District. In 1987, this exterior wall of the Stanyan Street campus was the last to be demolished. The Koret Health and Recreation Center now stands on the site. (Courtesy of St. Ignatius College Preparatory.)

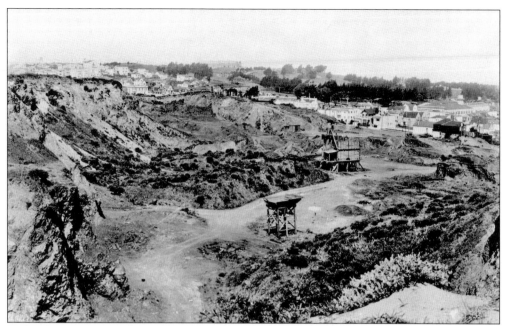

In April 23, 1923, a working quarry stood at Anza and Thirtieth Avenue. This land became the site of George Washington High School. This photograph looks northwesterly, with the Sutro Car Barn at the right and Lincoln Park behind it. (Courtesy of a private collector.)

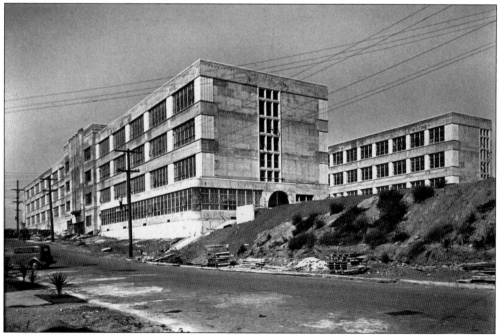

George Washington High School, the only public high school ever built in the Richmond District, opened on August 25, 1936. It was designed by Timothy L. Pflueger, also known for the Castro Theatre, the 450 Sutter Building, and Roosevelt Junior High. This photograph, taken on Thirty-third Avenue shortly before the school was completed, shows the undeveloped land around it. (Courtesy of San Francisco History Center, San Francisco Public Library.)

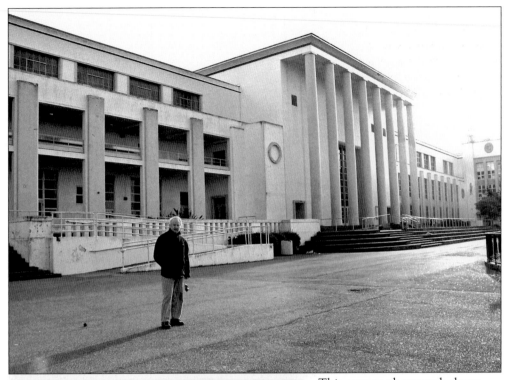

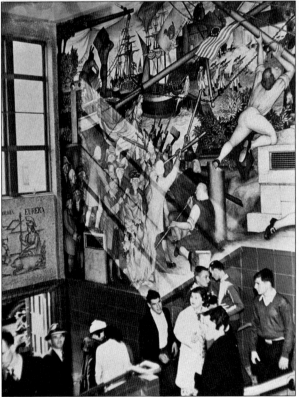

This current photograph shows Morrie Brobrow, student body president in 1957, on the esplanade at George Washington High School. (Photograph by Sharon Lang Bobrow.)

A unique feature of the high school is the 1600-square-foot interior murals painted by Victor Arnautoff as part of a Works Project Administration (WPA) project. The frescos depicted scenes from the life and times of George Washington. Another mural, a stone frieze that sits over the football field, was sculpted in 1942 by Sargent Johnson. In the 1970s, an additional mural by Dewey Crumpler was commissioned to give a more balanced view of contributions by minorities. (Courtesy of San Francisco History Center, San Francisco Public Library.)

Sharon Lang Bobrow sat recently in the stands at the Washington High School field, where fans are treated to a "million dollar view." (Photograph by Morrie Bobrow.)

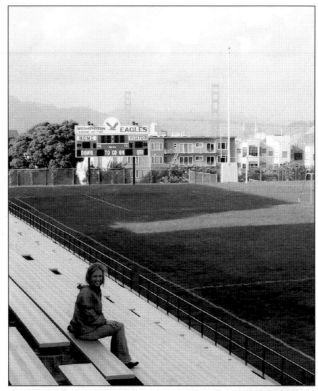

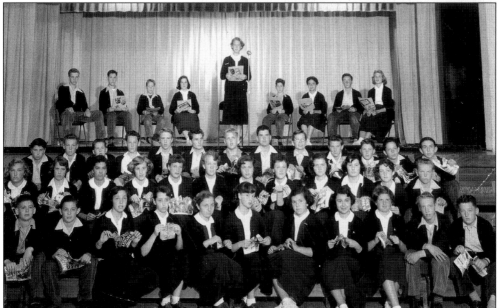

John Freeman (blond, back row center) was in seventh grade at Star of the Sea School when this 1954 photograph was taken. At an assembly for upper grades, speakers lectured about the evils of comic books. The keynote speaker was Elizabeth Cahill (center), daughter of police Chief Thomas Cahill. The students in the bleachers are tearing up the evil comics, which today are prized collectables. (Courtesy of John Freeman.)

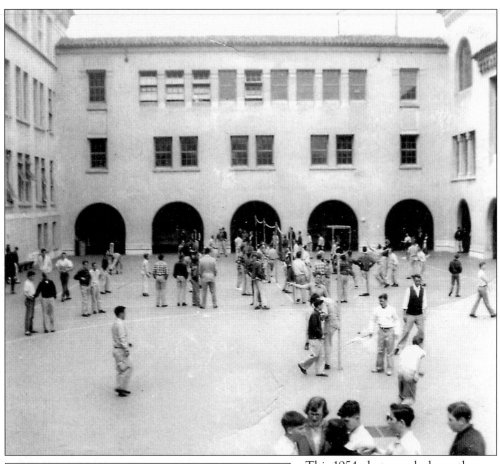

This 1954 photograph shows the yard at Presidio Junior High (now a middle school). (Courtesy of Isabel Nadel Hogan.)

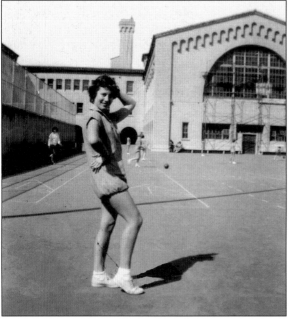

In 1954, Joan Dudak poses in her gym outfit at Presidio Junior High School. (Courtesy of Isabel Nadel Hogan.)

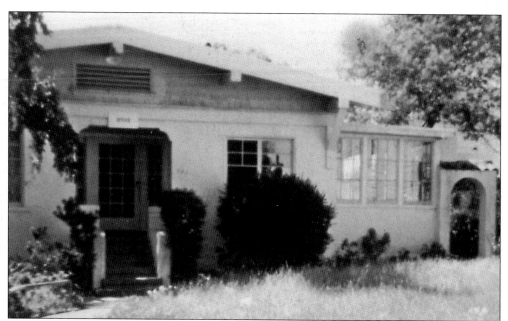

In 1947, Lucinda Weeks opened a school for handicapped children at her home on Belvedere Street. When the building was condemned in 1950, the school moved to 741 Thirty-first Avenue, into several buildings (one of which is shown here) owned by the San Francisco Unified School District. Lucinda Weeks died in 1962, and the school closed for financial reasons on October 31, 1967. (Courtesy of Dorothy Noble Cox.)

In 1980, the San Francisco Unified School District announced plans to raze Lucinda Weeks School and build condominiums. Dorothy Noble and Dennis Rice cofounded "Save Lucinda Weeks School" to help the community protest the move. This poster announced a fund-raising carnival on June 14, 1980. The group convinced the city not to destroy the buildings, and the Richmond District Neighborhood Center (RDNC) was born. (Courtesy of Dorothy Noble Cox.)

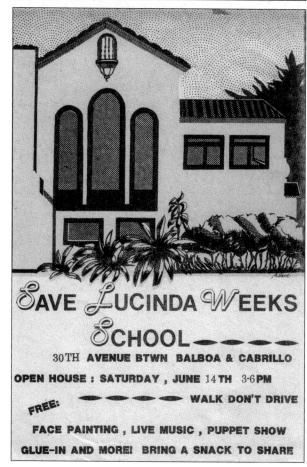

SAVE LUCINDA WEEKS SCHOOL————
30TH AVENUE BTWN BALBOA & CABRILLO
OPEN HOUSE : SATURDAY , JUNE 14TH 3-6PM
FREE: ————◆ WALK DON'T DRIVE
FACE PAINTING , LIVE MUSIC , PUPPET SHOW
GLUE-IN AND MORE! BRING A SNACK TO SHARE

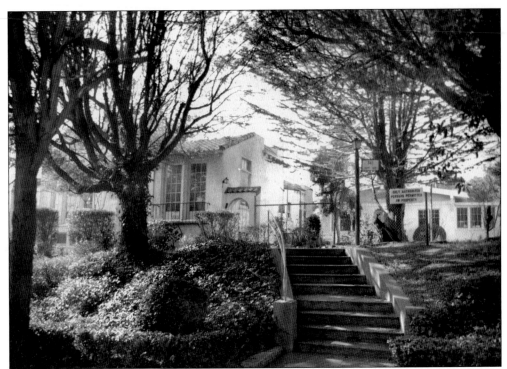

This 1980s photograph shows the RDNC in its early days. Today RDNC is a thriving, multipurpose, multiethnic community center offering after-school programs, day camps, adult services, and more. (Courtesy of Richmond District Neighborhood Center.)

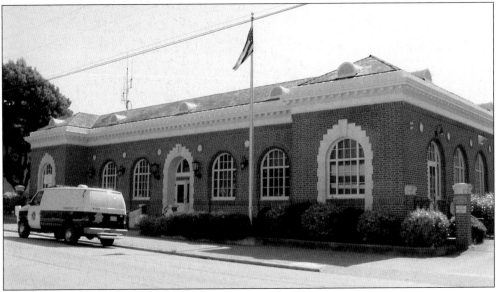

Other public buildings serving the growing neighborhood included a police station, libraries, hospitals, and a retirement home. The Richmond District Police Station opened on February 12, 1912. The building in the back housed horses with a loft to hold their feed. The building was renovated in 1990, and the horse building now boasts a neighborhood community room. (Photograph by Lorri Ungaretti.)

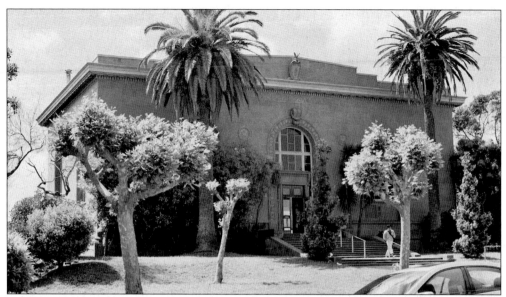

In 1892, the first Richmond District public library opened at 809 Point Lobos Avenue. In 1897, it moved to 254 Fourth Avenue (in the back of a candy store!). The district now boasts two library branches, the Anza Branch at 550 Thirty-seventh Avenue and the Richmond Branch (shown here) at 351 Ninth Avenue. Built in 1914 with funds provided by Andrew Carnegie, the Richmond Branch is the fourth public library branch in San Francisco. It was designed by Bliss and Faville, known for the Geary Theater and St. Francis Hotel. (Photograph by Lorri Ungaretti.)

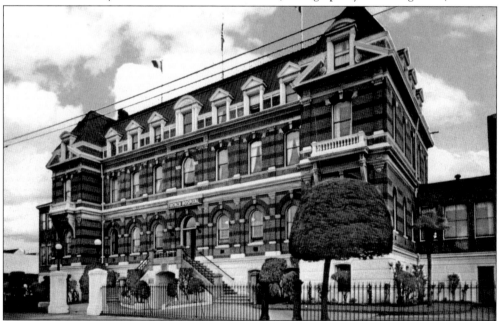

The French Hospital was founded in 1851 by the French Mutual Benevolent Society. The society built a new hospital in the Richmond District after Francois Louis Alfred Pioche gave the society $5,000 and two acres of land from Geary to Anza, Fifth to Sixth Avenues. In 1895, the hospital opened. This postcard shows one of the original buildings. The hospital is now Kaiser Permanente's French campus. (Courtesy of John Freeman.)

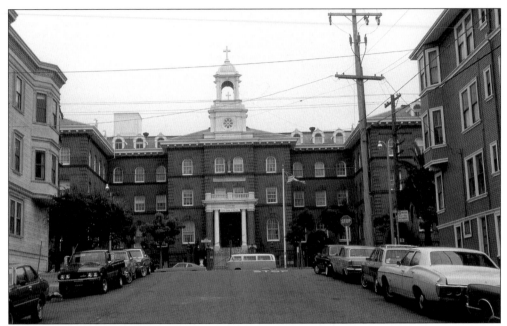

The Little Sisters of the Poor at 300 Lake Street is a home for the aged poor, operated by a Catholic Order of nuns. In 1902, businessman Joseph Le Breton donated $100,000 for this new building. Designed by Albert Pissis, the building eventually cost Le Breton $342,540. The home opened in May 1904, and for years, Le Breton and his brother served dinner to the residents on Christmas and other holidays. (Courtesy of Dennis O'Rorke.)

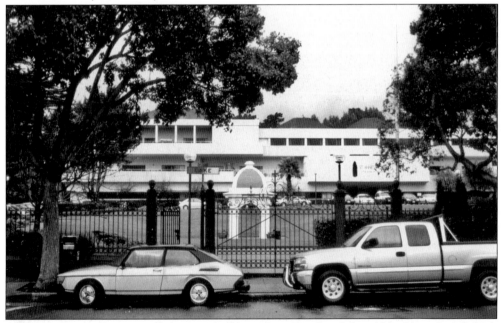

In 1979, a new Little Sisters of the Poor building was erected and the old building demolished. The original tower cupola now sits on the front lawn. After the 1906 and 1989 earthquakes, refugees stayed at Little Sisters of the Poor until they could find other places to live. (Photograph by Peter Field.)

Six

Daily Life

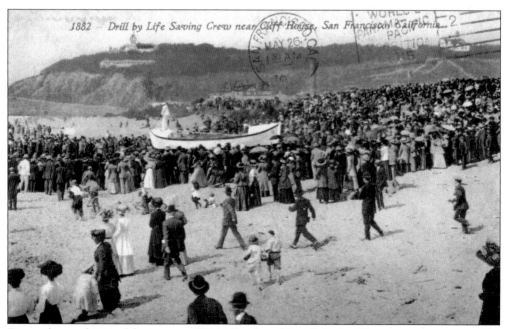

1882 — Drill by Life Saving Crew near Cliff House, San Francisco, California — 2

Due to the roughness of the waters at Ocean Beach and Land's End, a lifesaving crew maintained a station at the Great Highway. Drills became an event worth watching, as evident in this postcard, c. 1910. (Courtesy of Mark Adams.)

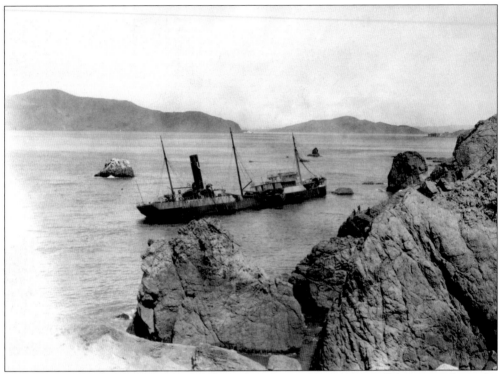

Over the years, many ships sank at Land's End, and parts of some can still be seen at low tide. On October 7, 1922, the *Lyman Stewart* became lost in the fog, turned, and was rammed by a freighter. (Courtesy of Emiliano Echeverria.)

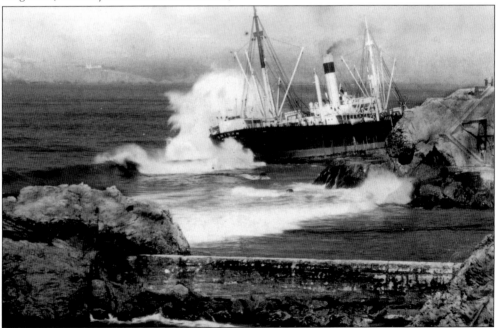

On October 7, 1936, 14 years to the day after the *Lyman Stewart* sank, the *Ohioan* was wrecked near Seal Rocks. (Courtesy of Rita Dunn.)

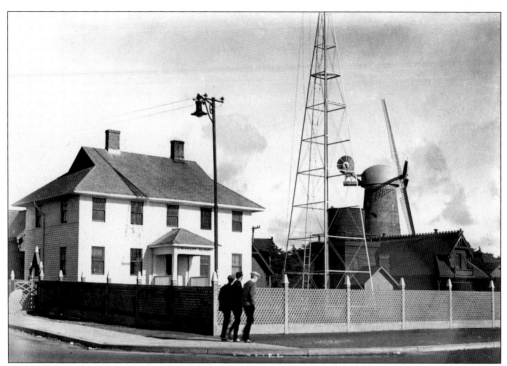

This lifesaving station stood at the corner of Fulton Street and the Great Highway until 1951. (Courtesy of Emiliano Echeverria.)

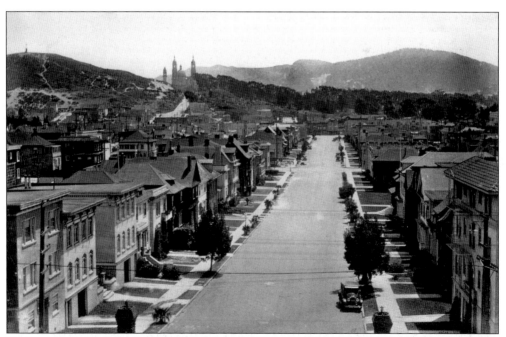

Farther inland, daily life in 1925 included manicured lawns and few cars. This view of Commonwealth Avenue looks south from California Street. The towers of St. Ignatius Church stand out in the background. (Courtesy of John Freeman.)

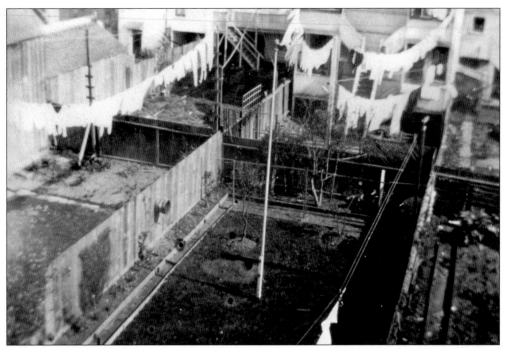

An early 1900s view of the backyards in the Richmond showed laundry day—"always Monday." (Courtesy of Virginia Cronyn.)

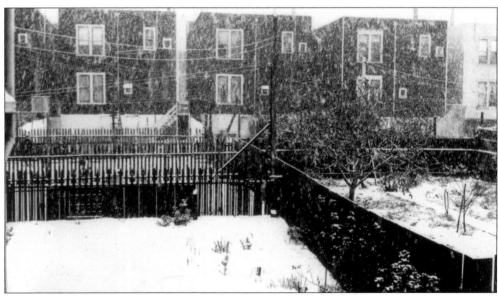

On December 11, 1932, Mark Adams's great aunt Edna Geiger captured rare falling snow from her Richmond District window. (Courtesy of Mark Adams.)

Oscar Schori, a chef at the Fairmont Hotel, was proud of his little garden at the back of his new home on Twenty-Ninth Avenue near Cabrillo, c. 1926, still surrounded by sand dunes. (Courtesy of Dorothy Noble Cox.)

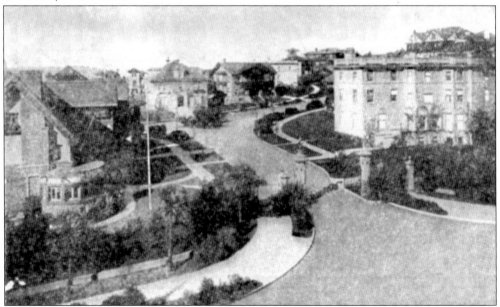

Presidio Terrace is an oval-shaped development tucked away north of Lake Street and west of Arguello Boulevard. Laid out in 1904, it was a unique "in-town suburb" that featured curving streets (instead of grids) and larger lots than those in older residential neighborhoods. Presidio Terrace would serve as a model for other park-like neighborhoods in San Francisco. This 1915 photograph appeared in an advertisement for Presidio Terrace. (Courtesy of Richard Brandi.)

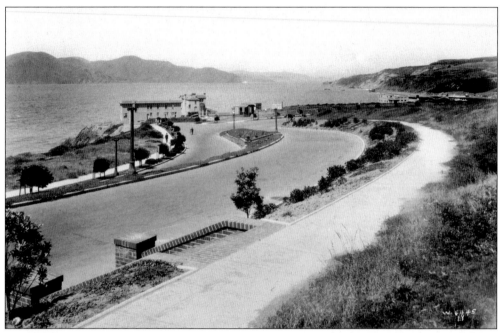

In 1925, development had just begun in Sea Cliff, an exclusive area along the bay on the northern edge of the Richmond District. The sidewalks and steps were in place, but only one house had been built. This view facing the Golden Gate was taken a decade before the bridge was built. (Courtesy of California Historical Society, FN-12654.)

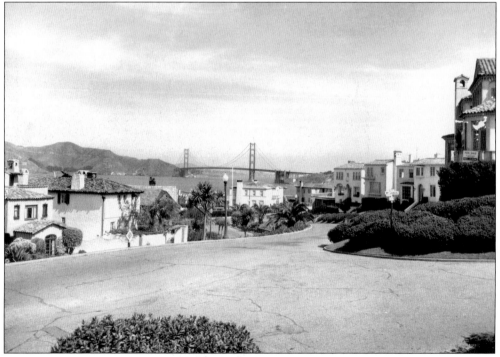

By March 27, 1953, much of Sea Cliff had been developed and the bridge was clearly in view. (Courtesy of Pacific Gas and Electric Company.)

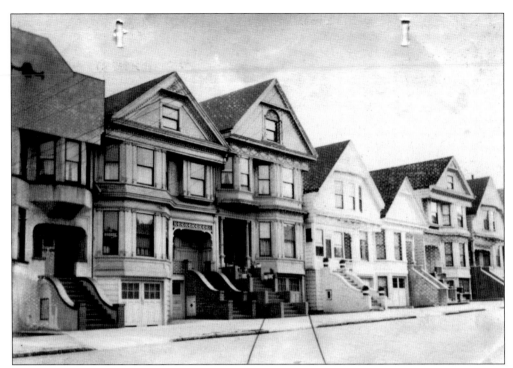

Developer Fernando Nelson, with his four sons, was one of the San Francisco's most prolific homebuilders in the early 20th century. According to *The Call* newspaper on May 10, 1913, Nelson "has been the largest builder in the Richmond District." He also built homes in West Portal, the Mission, the Sunset, and Merced Manor. This 1938 photograph shows some of his houses on the 600 block of Third Avenue. (Courtesy of Julie Norris O'Keefe.)

Future historian Jack Tillmany, author of Arcadia's *Theatres of San Francisco*, surveyed his domain from the vantage point of Twenty-seventh Avenue and Geary in July 1937. (Courtesy of Jack Tillmany.)

An unidentified family posed for this 1930s photograph on the 500 block of Fourth Avenue. Note the Little Sisters of the Poor building (see page 100) at the end of the street. (Courtesy of a private collector.)

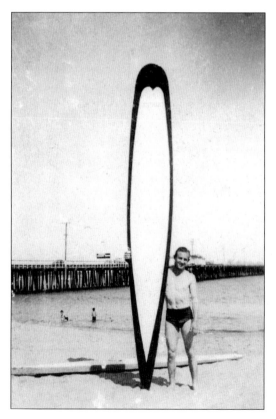

A group of children who grew up near Cook Street became lifelong friends, calling themselves the "Village Boys." When they were young, they met regularly at a store on Blake Street; later, they met once a year for 50 years. When Marty Larkin, one of the Village Boys, was 14, he "learned to make a 12-foot-tall surfboard of plywood and pine from an article in *Mechanics Illustrated*. My friends and I put the board on the top of a 1937 Ford, and we drove to Santa Cruz to try it out." The surfboard weighed about 50 pounds. (Courtesy of Dennis O'Rorke.)

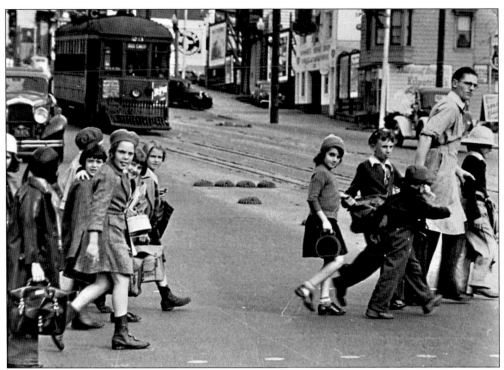

On November 5, 1937, the newspaper printed this picture, saying that neighborhood grocer H. E. Koenig escorted a group of children safely across Cook and Geary from the John Geary School. "It's a job frequently taken over by friendly clerks when traffic officers are not available—it's the only way children can cross streets safely at such times." (Courtesy of San Francisco History Center, San Francisco Public Library.)

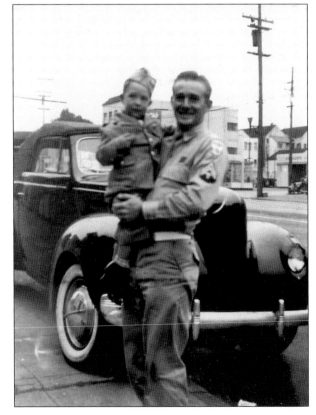

Marty Larkin, shown here holding his nephew Dennis O'Rorke, removed all the chrome, the front grill, and the running boards from his 1940 Ford convertible to make it "special, more modern." He also remolded the car's frame and hood, creating one of the area's first modified automobiles. (Courtesy of Dennis O'Rorke.)

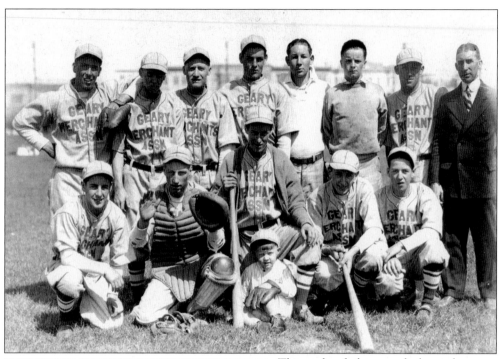

This undated photograph shows the members of the Geary Merchants Association baseball team. (Courtesy of Talullah Alvarez Mirabito.)

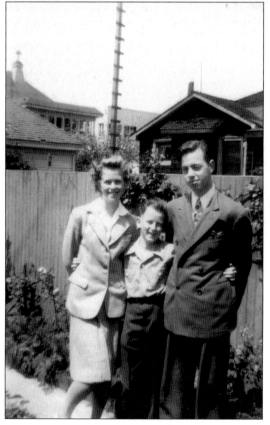

In the early 1940s, Lorraine Auld, Bob Mahoney, and Walter Mahoney posed in the backyard at 175 Parker Street. Bob says, "Note the pole for hanging the wash line in the background. I used to climb it!" (Courtesy of Bob Mahoney.)

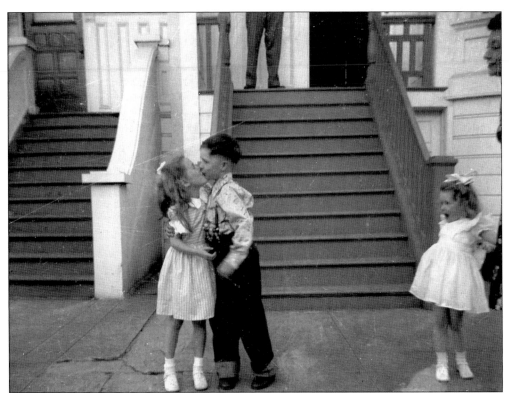

In this 1940s photograph, young Dennis O'Rorke kisses neighbor Margie Walker on Third Avenue between Balboa and Cabrillo. Dennis's sister Kathleen watches the action. (Courtesy of Dennis O'Rorke.)

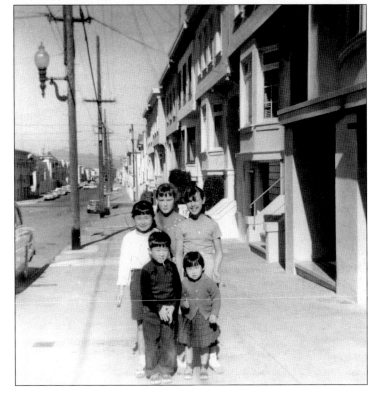

Neighborhood friends posed for the camera on Twentieth Avenue in 1959. Pictured here are (first row) members of the Ohashi family; (second row) Frances Ohashi, Julie Norris, and Margie Wayne. (Courtesy of Julie Norris O'Keefe.)

In 1950, the Hogan children dressed up for Easter across the street from their home on Third Avenue. Pictured, from left to right, are Mary, John, Ann, and Edward Hogan. (Courtesy of Isabel Nadel Hogan.)

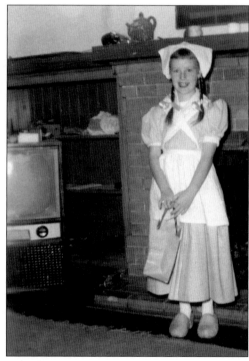

Around 1957, Julie Norris posed in this Dutch girl costume made by her mother. She is standing in a Richmond District friend's living room, next to a modern television set, which she said was "the first one on the block." (Courtesy of Julie Norris O'Keefe.)

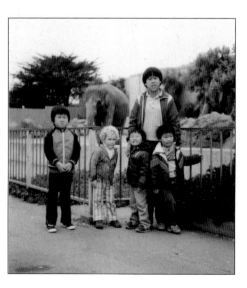

In 1980, Andrew Ausley (second from left) and his friends at Discoveryland Pre-School took a field trip to the zoo. The preschool still operates at 7777 Geary. (Courtesy of Dorothy Cox.)

In 1977, Heather Fong was a rookie walking the beat at Sixth and Clement with her colleagues: unidentified officer, Officer Heather Fong, then-Chief Charles Gain, and Officer Tom Mulkeen. In 2004, Fong became the first Asian American female in the United States to head a major urban police force. Over the years since becoming a police officer, Fong has built bridges between the city and growing Chinese American community. (Courtesy of Mark Adams.)

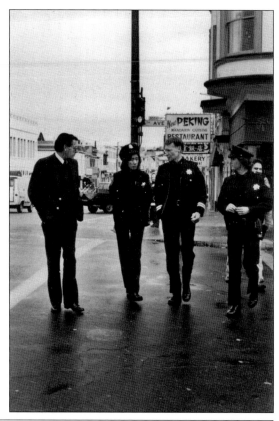

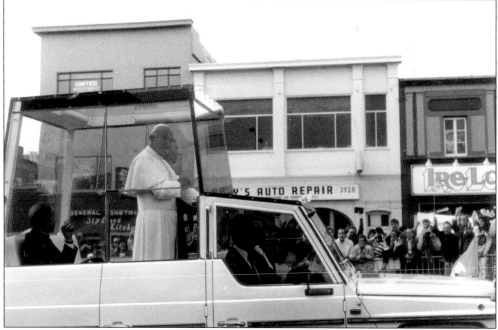

In 1987, Pope John Paul II came to San Francisco and traveled to the Richmond. In this photograph, the "popemobile" rides along Geary near Third Avenue. (Courtesy of Mark Adams.)

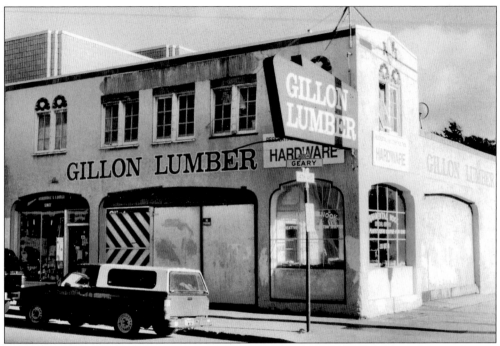

As the Richmond grew, more businesses moved to this neighborhood where property was cheaper and open space plentiful. One of the earliest businesses in the area was Gillon Lumber, founded in 1896 by Edward E. Gillon on Point Lobos Toll Road (now Geary) at Fourth Avenue. Gillon ran the business until his death in 1934. The store operated until 2002, when competition from large chain stores led to the store's demise. A produce market has opened in the building. (Courtesy of Philip Laborio Gangi.)

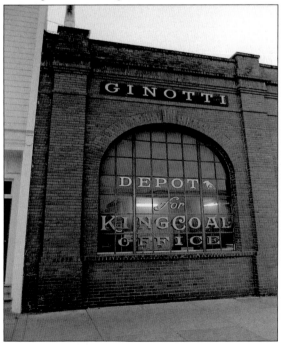

The Ginotti coal depot on Geary near Eighth Avenue sold not only coal but also oats, hay, and chicken feed. Built in 1908, the Ginotti building still stands, now providing the neighborhood with automobile service. (Courtesy of Dennis O'Rorke.)

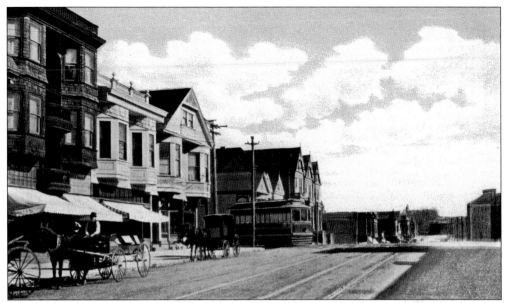

Clement Street has always been a primary location for Richmond District businesses. This 1905 postcard shows Clement Street looking east. Rounding the corner is a streetcar coming from Sixth Avenue. (Courtesy of John Freeman.)

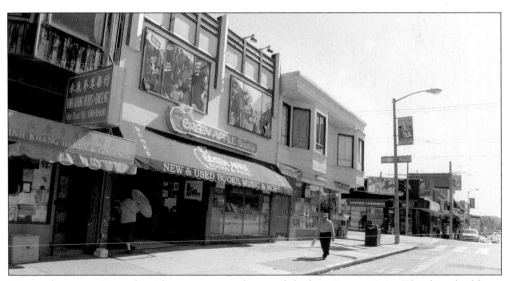

Here is the same view today. The streetcar tracks—and the horses—are gone. The three buildings in the foreground are original but have been greatly altered. Since 1967, the popular Green Apple Books has operated on this block. (Photograph by Kevin Hunsanger.)

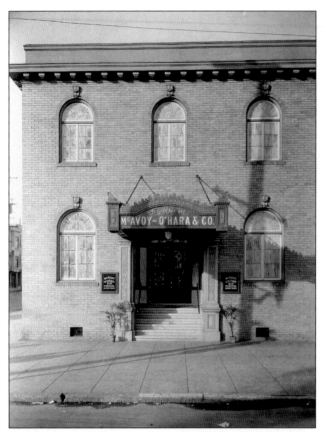

The oldest funeral home in the city, McAvoy O'Hara was founded in 1850 on Market Street. When the building was destroyed in 1906, McAvoy O'Hara became the first funeral home in the Richmond, moving into this building at Ninth Avenue and Geary. Later, the family-run organization built a structure at 4545 Geary and moved the business there in 1946. The Evergreen Mortuary of McAvoy O'Hara continues to operate at 4545 Geary. (Courtesy of McAvoy O'Hara.)

The building that housed McAvoy O'Hara in the early 20th century is now an apartment building. The entrance has changed, but the building looks much the same on the outside. (Photograph by Lorri Ungaretti.)

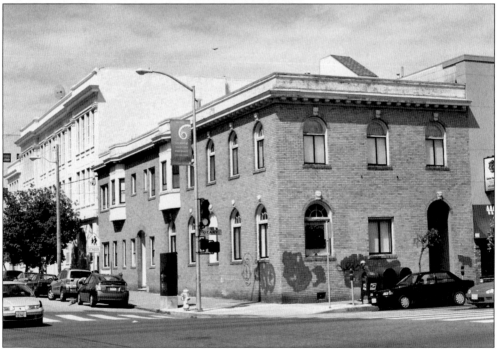

In 1849, the Boudin French Bakery was one of more than 60 bakeries in the city. After the bakery building was destroyed in the 1906 earthquake, Boudin moved to the Richmond District, rebuilding the bakery in a large barn at Geary and Tenth Avenue. Boudin now has more than 20 bakery-cafes in the San Francisco Bay Area, including the one at Geary and Tenth Avenue. (Photograph by Peter Field.)

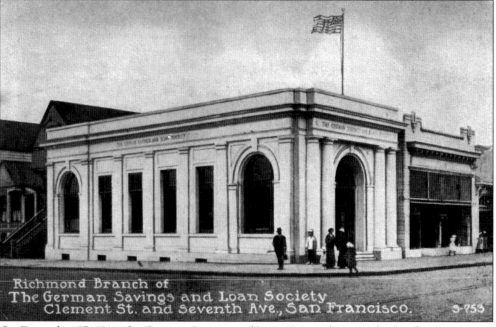

On December 27, 1911, the German Savings and Loan Society became the first bank to open a branch in the Richmond District. The building at 432 Clement Street still stands, now housing Tat Wong Kickboxing Center. (Courtesy of John Freeman.)

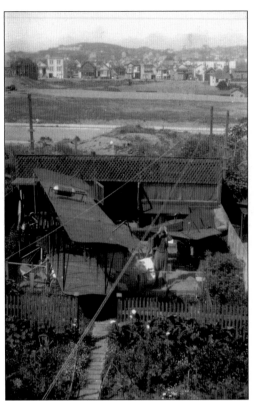

In 1915, twin brothers, Arthur and Willie Gonzales, aged 15, became famous for inventing a biplane glider. They lived at 435 Sixteenth Avenue and built the planes in their backyard. This photograph shows one of the brothers looking perplexed or dismayed by this accomplishment. (Courtesy of the Hiller Aviation Museum.)

Arthur Gonzales drew this sketch of himself in flight. Note the typo in the rubber stamp the boys used ("BORS," instead of "BROS"). Arthur and Willie advertised with a sign that read: "Aviators Wanted! Learn to fly and build. Private lessons—day and night courses. Gonzales Brothers, Expert builders & designers. Richmond District, San Francisco." (Courtesy of the Hiller Aviation Museum.)

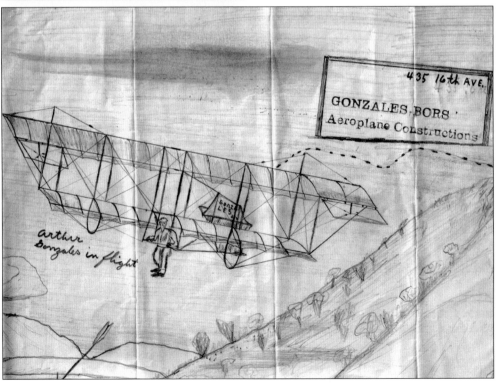

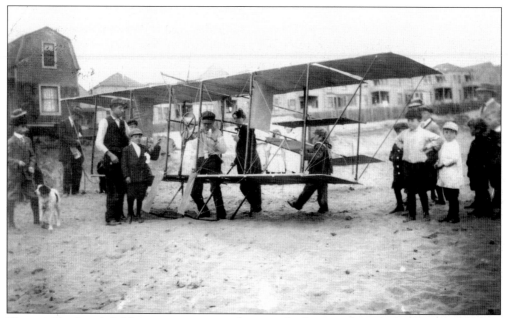

The neighborhood children came out to stand among the dunes and watch the Gonzales brothers with their biplane. Bob Gonzales, the boys' uncle, saved Gonzales planes and photographs and donated them to the Hiller Aviation Museum in San Carlos, California. (Courtesy of the Hiller Aviation Museum.)

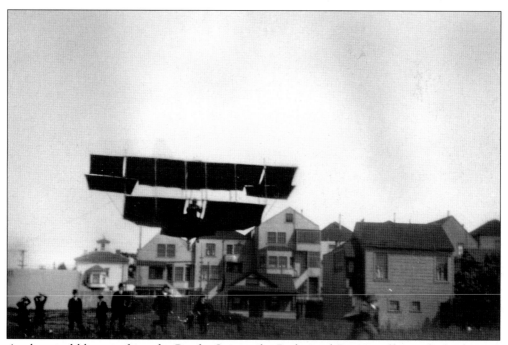

As the wind blows in from the Pacific Ocean, the Richmond District offers updrafts that are ideal for flying. However, this Gonzales biplane flying over the neighborhood in 1915 was still an unusual sight. (Courtesy of the Hiller Aviation Museum.)

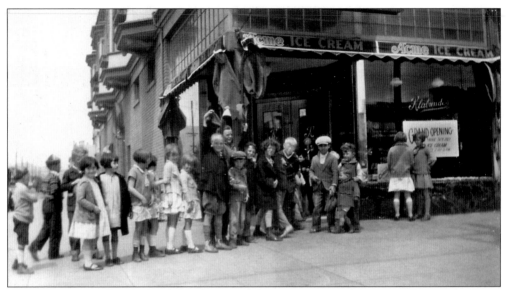

On May 1, 1927, Bill and Ella Klabunde opened their ice cream parlor at Twenty-second Avenue and Geary. On opening day, children lined up for free samples. The store became an institution in the neighborhood. For many years, people went to Klabunde's to pay their phone and PG&E bills; buy ice cream, candy, or school supplies; or just visit with neighbors. Bill and Ella Klabunde, German immigrants who were married for more than 60 years, ran Klabunde's from 1927 to the mid-1960s. (Courtesy of Tallulah Alvarez Mirabito.)

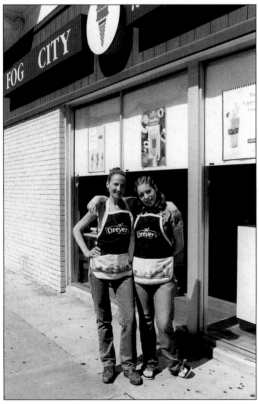

In the 1960s, a Baskin-Robbins took over the ice cream parlor. Tallulah Alvarez, a friend of the Klabundes for many years, opened Fog City ice cream parlor on the same site in April 2000. Alvarez (shown here with friend Stephanie Mirabito) ran Fog City for about a year. The store is still an ice cream parlor. (Photograph by Philip Liborio Gangi.)

Around 1941, a crowd stands outside Tigges Jewelers at 5847 Geary, possibly "to watch a factory salesman who occasionally demonstrated a coffee maker and handed out free coffee and cookies." Ed Tigges opened his first store at 2219 Clement Street in 1932 and later moved to Geary. (Courtesy of Linda Tigges Kayden.)

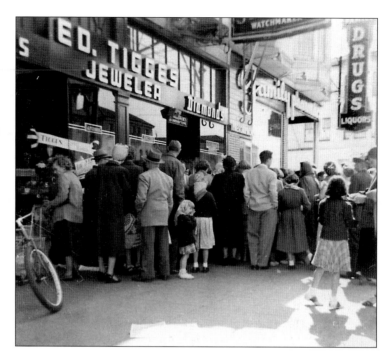

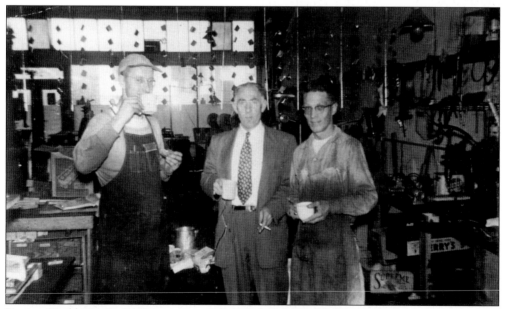

During World War II, Ed Tigges, center, designed a cigarette lighter while serving in the armed forces. The Tigges Snapmatic opened and lit with one motion, instead of the two required by earlier lighters. According to nephew Charles Haller, Tigges opened a cigarette lighter factory on Balboa Street between Twenty-first and Twenty-second Avenues after the war. (Courtesy of Karl Mondon.)

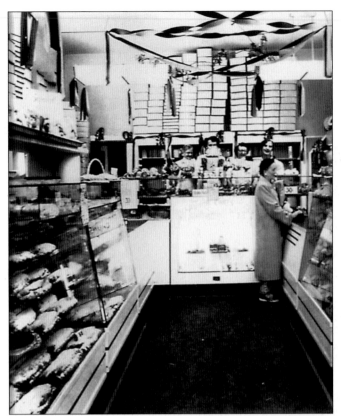

Opened in 1911, the original Schubert's Bakery stood on Fillmore Street. In the mid-1940s, it moved to 521 Clement Street. Lutz and Ralph Wenzel, owners since 1995, are fourth-generation pastry chefs. (Courtesy of Schubert's Bakery.)

In February 1953, firemen were cleaning up after a three-alarm fire on Clement Street. Note Schubert's Bakery in the burned building. The bakery still operates at this site. (Courtesy of San Francisco History Center, San Francisco Public Library.)

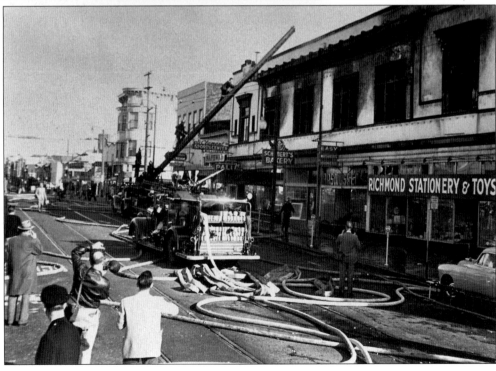

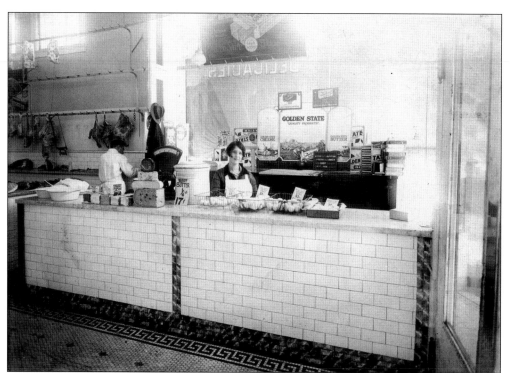

In the late 1940s, Ruth Geffen Stephenson stands at work in the Lincoln Market at Fifth Avenue and Clement Street. (Courtesy of Ron Stephenson.)

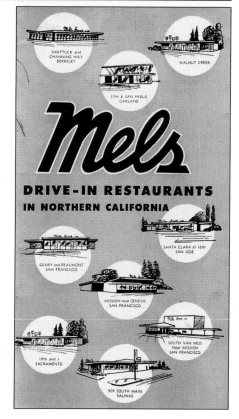

In 1947, Mel Weiss and Harold Dobbs opened the first Mels Drive-in Restaurant. It soon expanded to 11 sites, including the one on South Van Ness, seen in the movie *American Graffiti*. This menu, from the Mels on Geary at Beaumont, advertised all nearby Mels: San Francisco (three locations), Berkeley, Oakland, Sacramento, Salinas, and Walnut Creek. The Mels on Geary became a stereo store in the 1970s but has since reopened as Mels. (Courtesy of Isabel Nadel Hogan.)

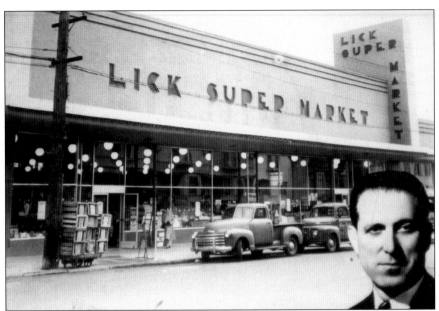

Lick Super Market at 350 Seventh Avenue opened in 1949. It was described as a "one-stop shopping center with abundant free parking." The inset is Frank J. Petrini, head of the meat department who later went on to found Petrini's markets around the Bay Area. The Lick Market site is now a Smart and Final store, and the windows that faced the street are covered. Part of the top of the original "Lick Super Market" sign was cut off, but the "A," "R," "K," and "E" are still visible down the side of the sign. (Courtesy of San Francisco History Center, San Francisco Public Library.)

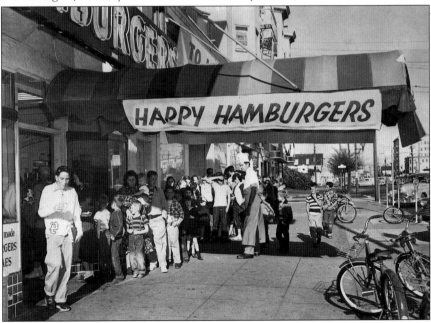

Customers lined up in front of Burgerville/Happy Hamburgers in 1952 because, as the newspaper explained, "Gordon Mailloux, owner, operator, and brave man, is going to give away free hamburgers in his restaurant at 14th and Geary on April first from 2 p.m. until 10 p.m., if he lasts that long." (Courtesy of San Francisco History Center, San Francisco Public Library.)

On June 9, 1959, a ceremony was held to announce the planting of trees on the median along Geary. Pictured, from left to right, are Hy Karp (light suit), president of the Greater Geary Boulevard Merchants Association; Mayor George Christopher (holding the shovel); chief of police Thomas Cahill; Leilani Michaels, designated "Geary Girl;" fire chief William Murray; and Evelyn Gutman, who finished third in the "Geary Girl" contest. Others in the photograph are members of the merchants association. (Courtesy of San Francisco History Center, San Francisco Public Library.)

In 1988, this Bank of America at Thirty-eighth Avenue and Balboa appeared in the movie *Patty Hearst* as the Sunset District Hibernia Bank that Hearst and the Symbionese Liberation Army robbed in 1974. Other movies with scenes filmed in the Richmond District include *Greed* (1924, Cliff House), *The Lineup* (1958, Sutro's), *Vertigo* (1958, Palace of the Legion of Honor), *Experiment in Terror* (1962, George Washington High School), *Take the Money and Run* (1969, a bank at 801 Clement Street), and *Harold and Maude* (1972, Sutro Baths ruins). (Photograph by Lorri Ungaretti.)

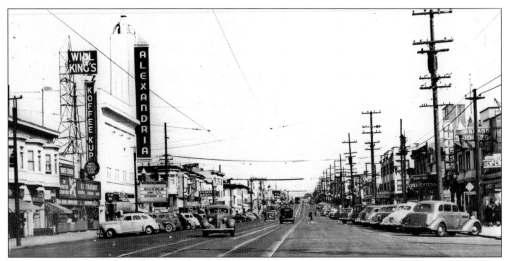

Geary has always been a major street for businesses. Prominent in this 1944 photograph is the Alexandria Theatre, built in 1923 at the corner of Eighteenth Avenue. The Alexandria closed in 2004. Other theatres that used to anchor the Richmond District include the Coliseum on Clement (opened 1918; closed 1989) and the Coronet on Geary (opened 1926; closed 2005). People may remember going to the Coronet to see *Ben Hur* and the *Star Wars* movies. (Courtesy of Jack Tillmany.)

The staff and "usherettes" of the Alexandria Theatre pose during a special showing of *Can-Can* in 1960 and are as follows: Dorothy Poole, Donna Baker, Fred Levin, Adele Goldblat, Carol Cross, Arlaine Plutle, Marlee Meharry, Laura Li Stiper, Jill Hosmer, Pat Leoni, John Masson, Larry Levin, and theatre manager Albert Levin. Actor Richard Egan, a graduate of St. Ignatius High School, was an usher at the Alexandria. (Courtesy of Jack Tillmany.)

Only three small theatres remain in the Richmond District: the 4-Star, the Bridge, and the Balboa. The Balboa Theatre, at 3630 Balboa Street, opened on February 27, 1926, as the "New Balboa" to distinguish itself from a theatre then on Ocean Avenue. In 1978, it was split into two screens, but it remains one of the few privately owned neighborhood theatres in San Francisco. (Photograph by Tom Gray; courtesy of Jack Tillmany.)

The San Francisco Recreation and Park Department has set aside this lot at the corner of Balboa Street and the Great Highway to be maintained as a sand dune. In 2002, the city dumped a load of sand on the site, and according to the *San Francisco Chronicle*, "the dune started acting like a dune." A local was quoted saying, "The sand would blow everywhere." This is one of the few natural sand dunes left in the city. (Photograph by Lorri Ungaretti.)

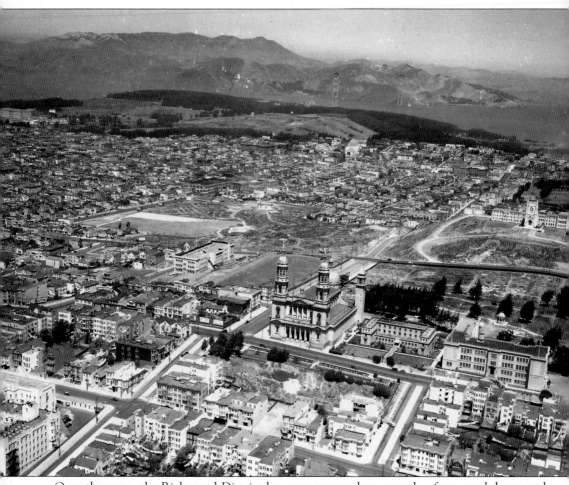

Over the years, the Richmond District has seen tremendous growth—from sand dunes and cemeteries, through roadhouses and amusement centers, to the thriving residential neighborhood it comprises today. This mid-1930s aerial view shows many neighborhood landmarks. The towers of St. Ignatius Church are prominent. Next to the church stand the early buildings of University of San Francisco (USF). Behind those buildings is Lone Mountain, with the San Francisco College for Women (now part of USF) at the top. The large plot of empty land at the center of the photograph is the former site of Odd Fellows Cemetery. Note that the cemetery's Columbarium stands alone. Below the cemetery land is Rossi Playground and the old St. Ignatius High School. In the far distance, the Temple Emanu-El dome is visible. (Courtesy of Steve Proehl and of California Province of the Society of Jesus Archives, Los Gatos.)